What **Alexander McQueen** Can Teach **You** About **Fashion**

 FRANCES LINCOLN

Ana Finel Honigman

Contents

The Inspiration

The Looks

The Details

Introduction

Lee to his friends and Alexander to the world, McQueen had a unique alchemic gift of turning personal tragedy, pain and torment into era-defining beauty and art while casting light on social injustices. McQueen's work accomplished the best purposes of art: to provoke a more nuanced understanding of ourselves and empathy for others.
His operatic intensity reminded a tactical industry of its sensuality. He made clothes that viewers wanted to touch and wearers could rely upon to express themselves. He brought sex and emotion onto the catwalk, reminding viewers of life's omnipresent truths.

McQueen's fashion teaches us that art's impact isn't bound to its medium but rather its creator's integrity, intellectual curiosity, empathy and sense of adventure. When McQueen started making clothes, the idea that fashion was an art form was restricted to a select roster

of austerely sculptural designers. Due to their experimentation with proportions and a colourless palette, rendering bodies almost invisible and sexless and highlighting the wearer as an intellectual, Issey Miyake, Rei Kawakubo and Ann Demeulemeester were designers whose clothes acted as the uniform for the art community. In contrast, designers such as Versace and Anna Sui were seen as pop-culture creatures – guilty pleasures. McQueen destroyed these divisions. He was a major influence in changing intellectual perception of fashion's status from frivolous to meaningful. Any argument undercutting McQueen's intellectual credibility showed itself as sheer snobbery. In 2011, a year after McQueen's death, New York's Metropolitan Museum of Art staged a retrospective exhibition of McQueen's work. *Savage Beauty* had more than 660,000 visitors in three months and was the eighth most popular show in the prestigious museum's history.

1969	1985	1992	1993	1996	2003	2010	2011
Lee Alexander McQueen is born in London, the youngest of six children.	McQueen leaves school and starts an apprenticeship on Savile Row.	McQueen debuts *Jack the Ripper Stalks His Victims*, as his Central Saint Martins Graduate collection.	McQueen sets up a studio in Hoxton Square and earns broad press attention.	McQueen is named the Head of Givenchy, a position he leaves in 2001.	McQueen is awarded the 'British Designer of the Year' for the fourth time and appointed a CBE.	McQueen dies by suicide in his London home.	The Metropolitan Museum of Art, in New York, stages the *Savage Beauty* exhibition of McQueen's work.

Turning pain into beauty

Through his personal identity

and the themes explored in his collections, McQueen fought to make fashion more inclusive and expose its entrenched prejudices, limitations and ugliness. He was no stranger to prejudice himself. As fashion journalist Dana Thomas wrote, '[Lee was] bullied by homophobic schoolmates, which pushed [him] to develop a violent temper and mouthy retorts as retaliation.'

McQueen's rage and humour merged into passion in his work. He used satire and danger as key tools to create unmistakably intense visions. Until only recently, fashion prided itself on maintaining and justifying restrictive, elitist boundaries. A class and beauty hierarchy, according to literally narrow standards, was a given among fashion's upper echelons. In the 1990s, avant-garde magazines like *The Face* and *Dazed & Confused* defeated elite titles like *Vogue* to promote photographers and models with accessible backgrounds, yet designers remained predominately from backgrounds similar to those of their uber-affluent consumers. McQueen, in contrast, was the son of a cab driver. He turned himself from Lee McQueen to 'Alexander' because friend, guide and partner Isabella Blow believed it made him sound posher, although he never hid his working-class origins. In fact, his background proved a motivating factor for his keen financial savviness: he lacked the sense of entitlement that so many of his peers had and was never shy about discussing money or advocating for himself, thus creating a more transparent conversation around the economic realities of being a designer – at all stages of his career.

He was aware of how uneasy traditional fashion editors and insiders were made by his weight, unstraightened teeth, east London accent, openness when talking about money and, of course, his ribald sense of humour. Labelled as an *enfante terrible* and 'the hooligan of English fashion', McQueen remained outside fashion's inner circles. Although he lost significant weight, sculpted his body and had his teeth cosmetically altered towards the end of his life, he never seemed fully to assimilate and instead helping push fashion towards the more expansive understanding of beauty and self-acceptance currently radicalising the industry today.

Embracing the shadows

McQueen's sexuality was knowingly different than his peers. As a survivor of childhood sexual trauma, McQueen was shaped by an acute awareness of power imbalances, danger, taboos and mistrust when it came to sex. Intimacy in McQueen's work was represented as raw, risky and confrontational. While designers like Calvin Klein or Tom Ford showed nudity as either an evocation of classical beauty or a form of flirtation, McQueen's sexuality was designed to arouse much darker lust and passion. He was inspired by London's sex clubs and the constant interplay between

sex, danger, death, violence and desire in subcultural scenes during the height of the AIDS epidemic.

Imagery and iconography about AIDS, from Robert Mapplethorpe photographs to public-service literature, influenced McQueen's identity as a gay man and artist. His friend, artist John Maybury, said 'kids like Lee were beginning to create their sexual identities at a time when this shadow, this spectre, was hanging over them.' Rather than flee, he invited that shadow in — as one component of his constant morbid consciousness.

Biographers have reported that McQueen was HIV-positive when he took his own life in 2010. Although the virus that causes AIDS had become more manageable through medication, the psychological impact of testing positive might have been a contributing factor in his suicide. An awareness of sex connected with death was undeniably one of the most potent and meaningful aspects of his art.

Sarah Burton, as the keeper of McQueen's legacy, honours the main aesthetic themes in the designer's work without attempting to replicate his unique energy. Burton joined McQueen's atelier as an intern and advanced to become his personal assistant. She was named creative director in 2010, designing the future Duchess of Cambridge Catherine Middleton's wedding dress the following year. Her polished, thoughtful work is more traditionally beautiful, amplifying the gentler aspects of McQueen's signature style while demonstrating her distinctly soft-spoken strengths. Burton says in a hundred years' time, the house of McQueen will be seen to have represented 'modernity and creativity and beauty and romance'.

Legacy

When Alexander McQueen died in 2010, aged 40, he was the world's most renowned and influential British designer, celebrated for creating art that addressed mortality and for living life at its extreme edges. All suicides are multifactorial combinations of chemistry and context and McQueen's choice to end his life can be seen as rooted in a wide range of factors — the trauma he suffered as a child, his disordered substance-use, the loss of his beloved mother. The profession-specific pressures of an industry demanding relentless creation and prioritising commercialism over creative integrity can also be factored in. These same issues also served as McQueen's creative influences though; perhaps his art enabled him to maintain a balance between life affirmation and a drive towards death. As McQueen himself said, 'my collections have always been autobiographical, a lot to do with my own sexuality and coming to terms with the person I am': for the designer they were like exorcising 'ghosts'. Through doing this, bringing his pain onto the catwalk in the form of fashion, McQueen also brought awareness to others equally beset by personal demons — showing them that pain can be turned into power and nothing, *nothing* at all, is more beautiful than survival.

The
Looks

Find the
Beauty in your
Nightmares

While other designers sought harmony and decorative beauty, McQueen used discord and darkness to make clothes with substance. He was unique in his ability to make some people recoil while resonating with many others. As he famously said, 'there is blood beneath every layer of skin.'

McQueen's ground-breaking 1992 graduate show at Central Saint Martins was titled *Jack the Ripper Stalks his Victims* and included hidden locks of human hair sewn into the seams. He entered the broader cultural arena with deeply challenging subject matter. *Highland Rape*, his Autumn-Winter 1995–96 collection, sparked his cultural significance. Comprised of tattered dresses on battered-looking models, the

→ Philip Treacy's headdress made from black ostrich feathers, silver, and black pearls melded death metal, horror cinema and history to poetic effect.

collection combined an autobiographical statement about his own experiences of witnessing domestic violence with those of historical trauma, as a person of Scottish ancestry confronting colonial abuses. Reflecting on the Scottish diaspora, McQueen incorporated imagery evoking individual violations and trauma. Later, he incorporated repeated references to BDSM, as a kink devoted to consensual exploration of boundaries, and made overt (sometimes problematic) political commentary inspired by current events and concerns.

McQueen revelled in revealing his – and the culture collective's – nightmares. A feathered helmet adorned with a metal skull and dagger as worn by a model wearing a light slip of purple lace for McQueen's 2001–2 *What a Merry-Go-Round* show, for example, created a haunting image. Half-siren and half-Valkyrie, the woman in this brutally beautiful outfit, with its purple ostrich feathers and beaded lace, appeared equally compelling and terrifying. Her power was

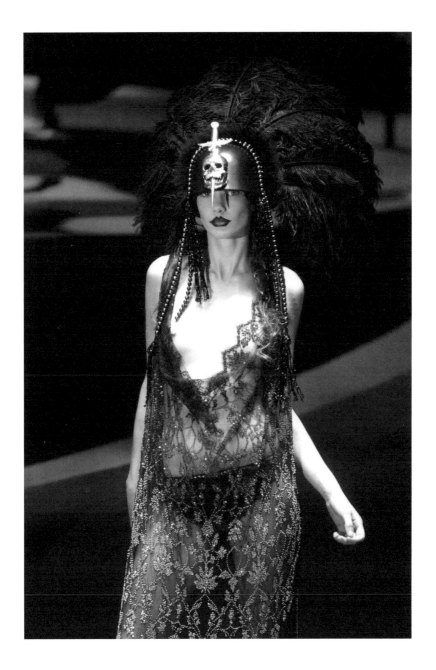

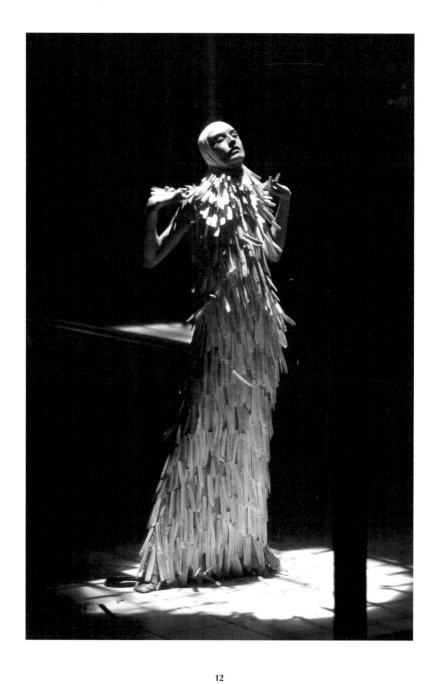

"I find beauty in the grotesque."

McQueen

inspired by the 1922 silent film *Nosferatu*, featuring a vampire preying on children. The show contained haunted harlequins, giant toys, ventriloquist's dummies and a gold skeleton attached to a model's ankle like a ball and chain. The theme song to the film *Chitty Chitty Bang Bang* was the show's only soundtrack. For *Voss*, Spring-Summer 2001, McQueen set his show in a sanitarium. The

← Erin O'Conner encased in thousands of razor-clam shells was a one-time performance piece. As McQueen said 'they outlived their usefulness on the beach' before becoming discarded symbols of beauty in distress and death for his catwalk.

models pressed themselves against a screen, silently screaming, while wearing silver thorns adorned with Tahitian pearls and ornately embroidered dresses or vests constructed from thousands of mussel shells. Model Erin O'Connor, her head wrapped in a white bandage, wore an asymmetric dress that had a bodice of red microscope-slides and a skirt entirely constructed of red and black ostrich feathers. Beautiful but unnerving, these couture pieces spoke to deeply embedded emotions and psychological tensions. McQueen's work, as art, evoked awareness of decay, disturbance and transcendence. 'I find beauty,' he said, 'in the grotesque.'

Be an
Alchemist

McQueen turned mundane materials into artworks and weaponised his working-class origins in a fashion world predicated on unobtainable luxury. He proudly talked about his lack of money and played with images of abjection in his early work. A pair of cutaway shorts, for example, was decorated with appliquéd cigarette butts for his Autumn-Winter 1995–96 collection. The need to be enterprising became a source of material and conceptual inspiration. When he couldn't afford high-end fabrics as a student, he sewed a zipper in a lace swaddle and transformed a bin bag into a slinky dress. In 2009, McQueen revisited rubbish bags as a medium by sending models onto the catwalk wearing bin liners as hats as a comment on a global recession. It also harked back to

→ Like Leigh Bowery, one of his creative soulmates, McQueen rejected internalized stigma over sensitive aspects of life and biography to turn vulnerabilities into power.

McQueen's boundaryless DIY innovation, his own self-effacing style highlighted his lack of resources and singular focus on feeding his collections with limited funds.

In 1993, art director Simon Costin snapped a portrait of McQueen hiding his face with black gaffer tape, allegedly because he had been on the dole when showing his first collection. In the documentary *McQueen*, the designer confesses to 'buying all my fabrics with my dole money and going round to my parents for baked beans and tins of soup'. Fear of being caught kept McQueen from attending his first American *Vogue* photo shoot but he continued finding clever ways of cutting corners to finance his creative vision. Conscious of money throughout his career, McQueen produced limited editions of his designs to avoid overextending his budget. He heeded the lessons of his peers and created unique showpieces, using his earnings to fund his haute couture label. In the end, his business acumen matched his artistic genius.

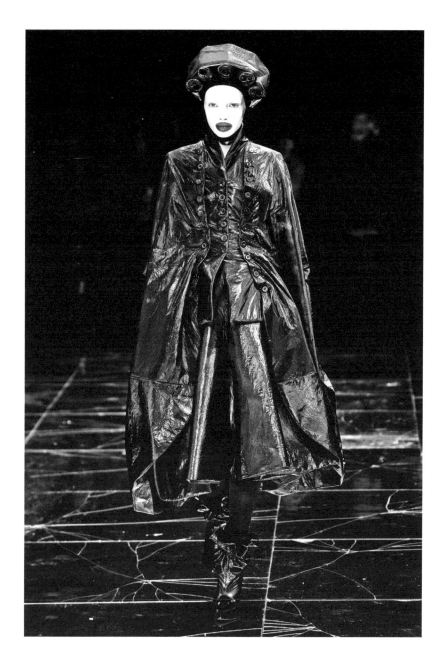

Challenge Gender

Gender, for McQueen, was one of many boundaries and cultural conventions ripe for subversion. He pioneered a uniquely nuanced and empowering perspective for women. The 1990s were filled with designers and artists pushing perimeters of gender normativity to open the cultural dialogue towards a greater acceptance and appreciation of gender fluidity. While many of McQueen's avant-garde predecessors and contemporaries, like Helmut Lang and Rick Owens, opted for a unisex aesthetic to transcend gender, McQueen combined archetypical masculine and feminine traits to celebrate women's strength while championing a pansexual erotic sensibility.

→ One of the most iconic and
iconoclastic garments of its era, the
McQueen bumster changed fashion's
relationship with proportions,
gender, class, and taste.

When McQueen revealed his bumster in his 1994 *Nihilism* Spring-Summer show, he touched base with his era's preference for androgyny. He presented the transgressive trousers on male and female models because of the universality of the sensitive area that his low-slung waistline spotlighted. By elongating the torso, he created a genderless sensuality. In his own words, the bottom of the spine, that's the most erotic part of anyone's body, man or woman.

Besides the bumsters, McQueen rarely focused on blurring gender boundaries; instead he pressed gendered archetypes hard against each other. In 1995, for example, he collaborated with fetish-icon Mr Pearl for his *The Birds* collection. The collection combined a homage to Hitchcock's irreverently sexual protagonist in *The Birds* with references to symbols of masculine courage used by sailors and skinheads. Alongside more conventional cis-female models, Mr Pearl, the world's foremost couture corsetière, wore a wasp-waisted

"... my collections have always been autobiographical, a lot to do with my own sexuality and coming to terms with the person I am."

McQueen

tailored jacket and pencil skirt, adorned with the collection's Hitchcock-inspired signature print. His slim tie, white shirt and make-up-free face cleverly contrasted his 18-inch-waist and surprising skirt, to create a striking, sexually charged interplay of masculine and feminine.

As McQueen stated, 'my collections have always been autobiographical, a lot to do with my own sexuality and coming to terms with the person I am.' The world surrounding McQueen was becoming increasingly progressive and polymorphous but binary understandings of sexual identity and gender remained prevalent. In McQueen's work, he obviously associated himself with his female wearers; they were the protagonists in a story based on his own. He sent women down the catwalk in clothes representing his inner being and life experiences, whereas many of his cis-male counterparts designed for women they saw as separate from themselves. Whether McQueen questioned gender within himself or fully embraced being a cis-gendered gay man, he told his story through his womenswear, breaking gender boundaries through allusion and creative innovation.

Get
Engaged

Fashion was a complex moral medium for McQueen. While many of his contemporaries appropriated references without seriously examining their wider societal ramifications, McQueen was deliberate with his statements. He asserted strong social criticism through his catwalk shows and couture creations. He championed a nihilistic aesthetic as a powerful gesture of rebellion against conventional constraints, while bringing broader concerns into a context commonly ascribed strictly superficial significance. By bringing the world, historical and contemporary, into his collections, McQueen turned clothes into high art.

→ The image of Scottish model and current art-dealer Honor Fraser wearing Shaun Leane's silver Crown of Thorns headpiece evokes Renaissance ecclesiastical imagery.

The sterling silver *Crown of Thorns* headpiece, designed by Shaun Leane for McQueen's Autumn-Winter 1996–97 *Dante* collection, exemplified McQueen's masterful mixing of contemporary concerns and historical references. The delicate accessory was a homage to Dante Alighieri's *The Divine Comedy* and simultaneously a protest symbol, evoking sacrifice and suffering. When asked by a journalist for *Time Out* about the collection's religious iconography, McQueen said, 'The show's theme was religion being the cause of war. Fashion's so irrelevant to life, but you can't forget the world.' Combining whimsy with brutality, the *Dante* collection pooled references to the Vietnam War, artist Joel-Peter Witkin's photography and visions of Christ's crucifixion from Alighieri's fourteenth-century allegorical poem. These disparate references were woven into a narrative account of human persecution and perseverance.

As an artist willing to take strong stances, McQueen's career included political

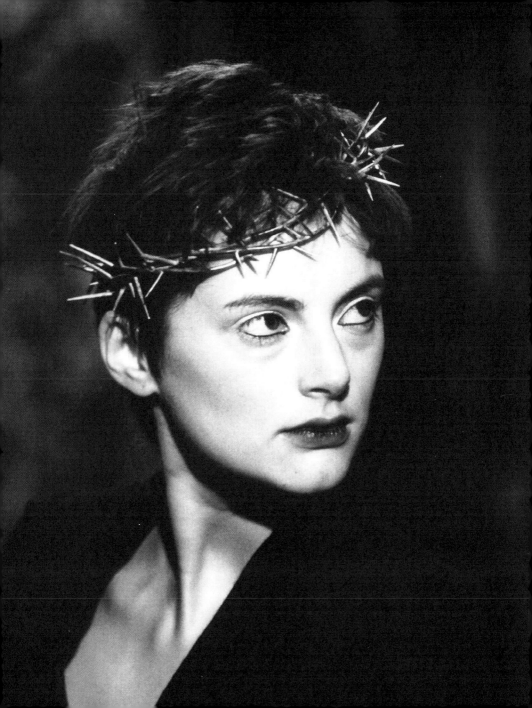

"Fashion's so irrelevant to life, but you can't forget the world."

→ When McQueen dropped his trousers in New York, as the conclusion of his Spring 2000 collection, he revealed American flag boxer shorts, punctuating his commentary on geopolitical tensions.

statements tainted by problematic content. For his highly criticized Spring-Summer 1999–2000 show *Eye*, McQueen juxtaposed fraught references from Islamic and Christian traditions as a critical commentary on America's foreign policy following Al-Qaeda's bombing of US embassies in Nairobi and Dar es Salaam. A niqab, worn by a model exposing her bare legs and knickers, carried the poisonous sting of cultural appropriation and desecration. McQueen's statement was more problematic than that of Turkish designer Hussein Chalayan, whose increasingly nude models in his 1997 Burka [italicised] show critically engaged Chalayan's culture from an insider's perspective.. His increasingly nude models in his 1997 *Burka*

show critically engaged Chalayan's culture from an insider's perspective. In his attempt to critique Islamophobia and cross-cultural female disempowerment, which McQueen stated were his intentions with the show, he sent models down the 100ft catwalk in New York to wade through ink-black water, representing oil; the show's finale involved models, including one wearing a burka and others in red-and-white-striped chadors, suspended with pulleys over metal spikes. For better or worse, *Eye* typified the strength of McQueen's convictions on various issues. Andrew Bolton, a curator at the Metropolitan Museum of Art, observed that McQueen's collections 'often channelled our cultural anxieties and uncertainties.'

Burn your **Idols**

Behind McQueen's game-changing rebellion was his profound and prevailing respect for fashion's history, craftsmanship and expressive potential. He used fashion as his method for attacking social constrictions while celebrating the medium's rules. His cutting and sewing techniques were so refined that his rebellion became irrefutable.

When McQueen dressed Debra Shaw in a transparent fringe and net dress, he shackled her elbows and knees in a metal cage. This powerful piece in his Spring-Summer 1997 *Le Poupée* collection both replicated the extreme contrasts of freedom and constraint that McQueen found in BDSM subculture and exemplified his design ethos. He was always swinging between tight precision and radical creative liberation.

→ Model Debra Shaw's modernist movements inside McQueen's metal cage replicated the uncanny intensity of Hans Bellmer's artwork and erotic restraints in BDSM.

This spirit interconnected with another defining creative group in the nineties and early years of the twenty-first century. McQueen rose through the fashion ranks in an era defined by deconstructivism, the style created by avant-garde designers, including Dries Van Noten and Ann Demeulemeester, and commonly known as the Antwerp School. This group of artistic creators unpicked seams, exposed linings and brought fashion to its fundamentals. Their work went against the excesses and opulence of eighties' fashion, where lavish sauces and garnishes drowned out ingredients. For the deconstructivists, like their peers in art, literature, poetry and design, beauty was about the process. They endeavoured to expose how things were made, to bring them down to their essence. McQueen also aimed to expose fashion's core but he rejected the deconstructivists' austere aesthetic. Instead of distilling fashion to its foundations, McQueen flaunted his technical mastery to lay bare fashion's pretentions and prejudices.

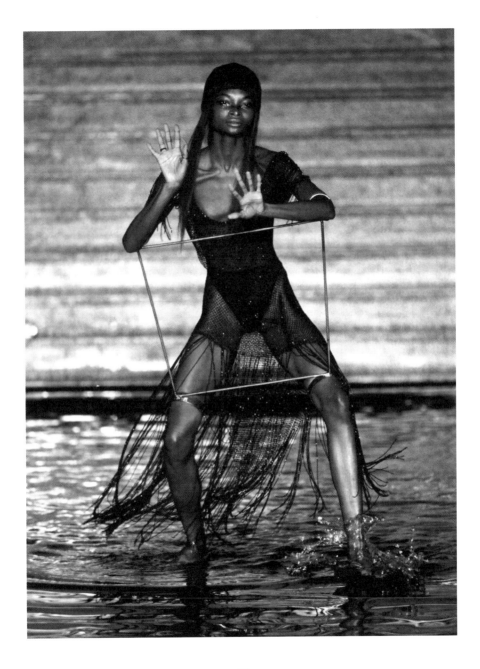

Practise
Dark Arts

When McQueen was asked about the omnipresent sexual subtexts of his signature aesthetic, he reportedly said, 'There has to be a perverseness to the clothes. There is a hidden agenda in the fragility of romance.' For him, with his personal history of transforming sexual trauma into creative conquest, sexuality and romance were always intermingled with darker psychological forces. He shared the philosophy of French theorist Georges Bataille, who claimed, 'eroticism is assenting to life up to the point of death'.

For McQueen, his clothes always mixed seduction with the macabre to become simultaneously titillating and intimidating. In his Autumn-Winter 2001–2 collection, a

→ The metal animal skeleton casually draped over an ethereal model's shoulder illustrates McQueen's comfort with dark energy and death's ubiquity.

model with monochrome clown makeup wore a slinky silk ballgown and heels, with a life-size silver skeleton gripping her ankle. Another model donned a skull-adorned helmet and a thin sheath of purple lace as a dress. Sex and death together, in equal proportion.

For his Spring-Summer 1997 *Le Poupée* collection, McQueen paid homage to one of art's most perennially disquieting figures, Hans Bellmer. This German artist crafted life-size nude pubescent female dolls that he dissembled and reconstructed as contorted, corpse-like figures for his deeply unsettling photographs and installations. Celebrating Bellmer's work, McQueen created a collection of stiff, flesh-coloured, garments worn by models who moved with uncanny rigidity through London's Royal Horticultural Hall. One look, shown by Kate Moss wearing a black wig and with thick silver paint across her face, consisted of pink jacquard trousers and a white sheer top with a horizontal open zipper under the nipples. Honor Fraser wore a crisp, fitted white suit with elongated

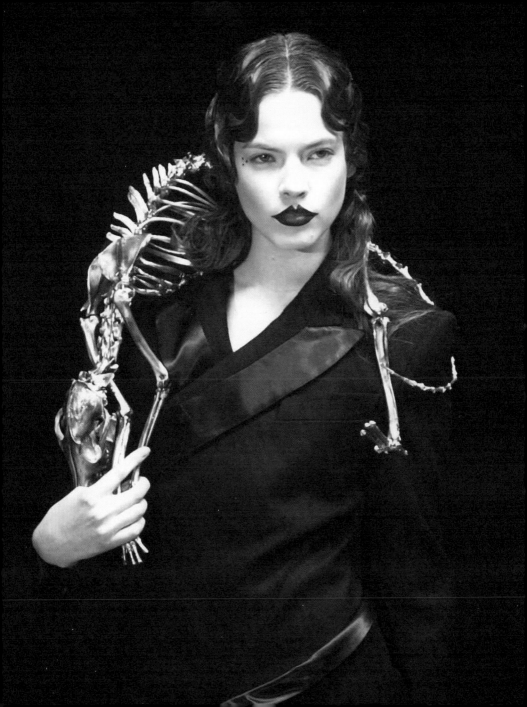

"Animals fascinate me
because you can find
a force, an energy, a fear
that also exists in sex.
There is no better
designer than nature."

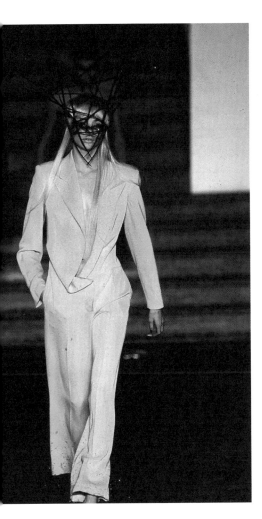

← Pink fabric folded like soft flesh creates an instinctually sexual drapery, appearing sophisticated and sleek from a distance yet atavistically erotic on a subconscious level.

lapels and low-slung trousers. A terrifying-looking metal hook sat around her neck, and protruded to one side, looking as if a chic version of the Grim Reaper's sickle was decapitating her. Jodie Kidd's entire face was enveloped in metal spikes, while her lilac suit was slashed to her navel. The contrast of delicate fabrics and aggressive metal drew attention to the models' skin. Their apparent comfort in exposing their vulnerability became a show of strength. As McQueen explained, 'There has to be a sinister aspect, whether it's melancholy or sadomasochist. I think everyone has a deep sexuality and sometimes it's good to use a little of it — and sometimes a lot of it — like a masquerade.'

Stay
Centred

When McQueen rose to prominence,
the prevailing beauty ideal for cis-female
models was boyish. A straight and narrow
line dominated nineties' catwalks and
editorials, with women striving for the
androgyne. McQueen was among the first
designers to directly reject this standard
or its mainstream variant of big breasts
and tiny hips. Instead of emphasizing
a line undermining sexual difference or
disproportionate femininity, he revitalised a
shape from art history and 1940s' fashion.
McQueen's signature became the hourglass.

Whether the rest of a garment floated
in sweeping waves or clung to the body,
McQueen consistently highlighted an

archetypically feminine waist. For McQueen's
Spring-Summer 2007 *Sarabande* collection,
for example, his friend and muse Daphne
Guinness wore a lilac tulle evening gown
inspired by Mae West. With exaggerated
hips and bust, the gown drew complete
attention to the model's waist, with its
contours outlined by Swarovski crystals.
Although adherence to this womanly ideal
has historically been weaponised to oppress
women with different body types, McQueen
used an hourglass shape to celebrate
women's power and strength.

A strikingly explicit example of McQueen's
connection between curves and power was
a bodice in 2007. White and decorated with
painted birds, the form appeared delicate
and wet against the model's body, which
seemed to emerge from within it. Looking like
a soaked sheet pressed against the woman's
skin, the bodice showed the outline of her
breasts, erect nipples and perfectly defined
six-pack abs — pitting the genteel print and
shape against her sheer physical authority.

→ Scientific theories hint that
hourglass proportions for cis-
women signal success in sexual
selection. Fashion shifts attention
to different body shapes and
beauty preferences but McQueen's
focus on historically feminine
curves signifies his admiration
for women's inherent power.

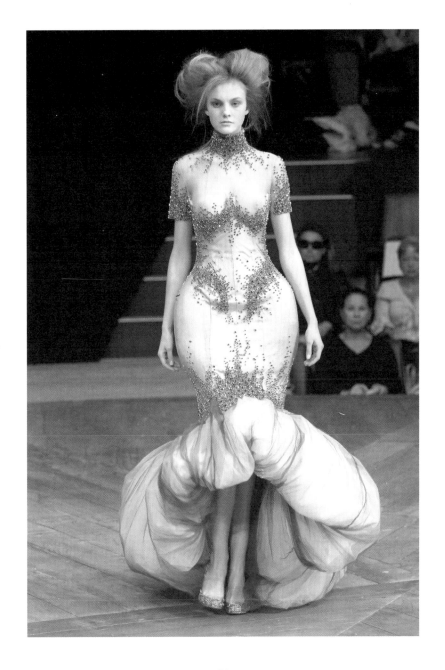

Seek the Animal Within

Animal skins, bones and prints ran wild through McQueen's oeuvre. The world, according to McQueen, could be aggressive, brutal, bestial, but also beautiful. In nature, beauty and brutality co-exist in constant struggle and harmony. McQueen similarly achieved a balance between beauty and ferocity with his use of prints, materials and cut. A black leather bodice with interlaced bondage straps overlaying a tight frame for his Autumn-Winter 2009–10 *The Horn of Plenty* collection was contrasted with full, glossy black, fox-fur sleeves, juxtaposing the slender body with soft, plush material. The impact was highly erotic – combining hints of pleasure and constraint, with an explicit and literal allusion to death in McQueen's use of fur and animal skin. A python-skin

→ The wicker and wire hat Philip Treacy created for McQueen's Autumn 2009-10 *The Horn of Plenty* collection appeared as an animal's open mouth omitting a brutal scream.

dress for his Untitled Spring-Summer 1998 show transformed the model into a predatory creature while demonstrating humanity's dominance over nature.

For his Spring-Summer 2009 show, McQueen symbolically protested environmental destruction by engineering prints based on nature. The show was staged in a former Parisian morgue and the catwalk was populated with antique taxidermized elephants, giraffes, tigers and their brethren. The collection reflected on the recent history of humanity's attack on nature, from the Industrial Revolution to the present day. Silk flowers pressed between layers of sheer fabric for mini dresses evoked of Victorian specimens and a sculptured minidress comprised of Swarovski crystals resembled clusters of live beetles encasing the model's body. The fabrics captured nature's intense, often garish colours and patterns. For his final bow, McQueen entered the catwalk in a dystopian rabbit suit – comical but creepy, like a horror-movie.

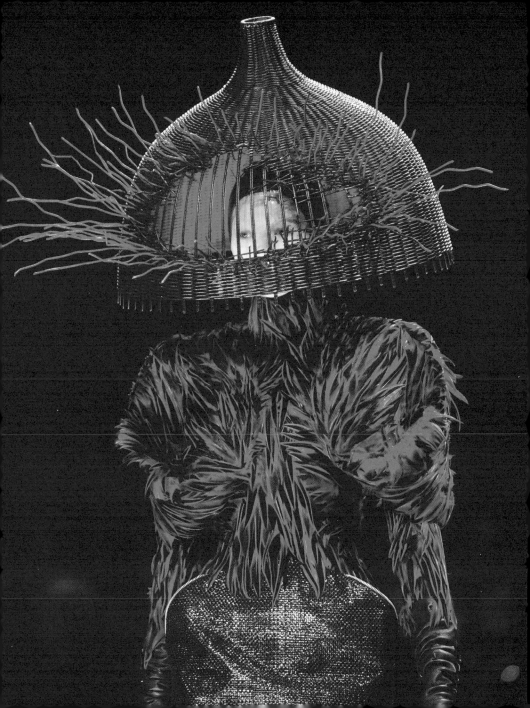

Make Waves

McQueen earned his skills on Savile Row and developed his aesthetic sensibility in London's nightclubs, but applied his mastery to creating opulent gowns fit for red carpets and museums. He is popularly known for skull scarves worn with skinny jeans and fitted blazers but his oeuvre is full of billowing, floating, sumptuous eveningwear. The lovely, life-affirming flow that McQueen created from luxurious fabrics provided a joyful counterpoint to his morbid motifs. The drama he generated with his larger-than-life skirts powerfully showed his personality and love of extremes. He was celebrated for his hard edge but he was a maestro of softness.

In 2003, his friend Daphne Guinness posed in a cream-coloured spill of ivory silk. This mille-feuille masterpiece, which started with a sculpted bodice and descended into streams of frills, was dubbed his Oyster dress because its texture resembled an oyster's shell and the colour was a pearl's off-white hue. A similar form appeared in the same collection but in rainbow silk-chiffon layers, with a pure red bodice and hem. For his *Widows of Culloden* Autumn-Winter 2006–7 collection, McQueen built layers and layers of pheasant feathers into a dress with a tight top and a gradually expanding skirt, which appeared to breathe on its own when the model moved.

A white silk underskirt, embroidered with gold thread, escaping from under a slender coat of gold-painted duck feathers for his posthumous *Angels and Demons* show, demonstrated McQueen's singular ability to balance freedom and contrast. A skirt of ostrich feathers connected a model's body to a team of taxidermised hawks attached to

→ Hundreds of rainbow-coloured chiffon layers comprise McQueen's technicoloured Oyster dress, which moved and flowed with electric energy.

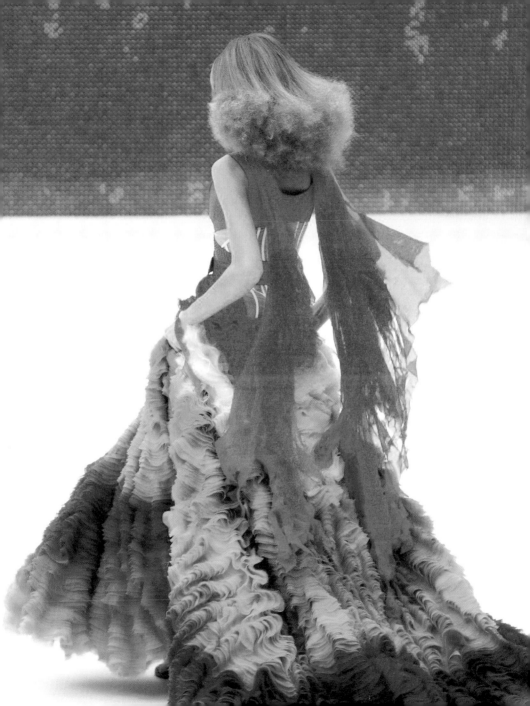

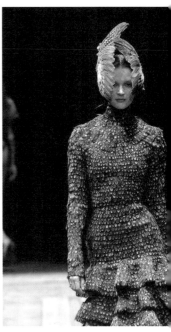

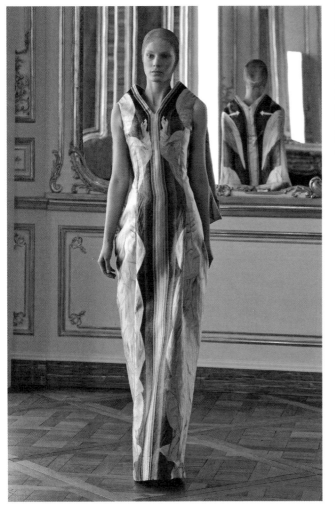

↑ For his 2006 Ready-to-Wear collection, McQueen's use of ruffles brought to life traditional fabrics *Vogue* appreciatively described as 'dragged down from ancient wall-hangings.'

← Delicate trompe l'oeil ripples along a column sheath in McQueen's posthumous collection eluded to his life-long interest in water's mystery and poetry.

"I oscillate between life and death, happiness and sadness, good and evil."

McQueen

her shoulders, while appearing to drape blue-grey silk across her chest. In McQueen's collection, a pale grey silk jacquard, printed with the image of the angel Gabriel from Hugo van der Goes' c. 1475 Annunciation of the Portinari Altarpiece, appeared to fill a room with floating fabric.

These majestic gowns can be seen as symbols of liberation and wonder for McQueen who said, 'I oscillate between life and death, happiness and sadness,

good and evil.' Free-flowing fabric might generate joy in a wearer or onlooker yet each McQueen garment contained its own internal complexity. The endless frills of his Oyster dresses were bountiful helpings of pure beauty but they also appeared to fall off the wearers' bodies, hinting at a tension between gravity and transcendence. Even in McQueen's most ecstatic and light-spirited moments, the prettiness of his creations was tinged with darkness.

Forbidden Florals

'Things rot …,' McQueen said when explaining his choice to intersperse fresh cut flowers with silk ones for a dress in his 2007 Spring-Summer show. 'I used flowers because they die.'

For McQueen, a perennially twee motif in English textile history carried his signature brand of poignant morbidity. With origins in Asia, floral lace and embroidery gained significance in fifteenth-century European fashion and later dominated English interior textiles thanks to William Morris. Floral fabrics conceptually captured flowers' fleeting, fragile beauty. Wearers benefited from the association with flowers that lasted forever. This was a look that McQueen harnessed as a surprising signature.

→ Covered in silk and fresh flowers, which faded and fell, this nude dress from 2007 became one of McQueen's signature garments, representing his conflicted relationship between life and death, nature and art.

Roses were McQueen's favourite flower. In 1997, he presented a second-skin black leather dress laser-cut with rose patterns across the model's pelvis. Embroidered burlap, in 1999, created the look of a rough, base, common sack made magnificent by the ornate roses stitched into its scratchy surface. The juxtaposition of a historically valueless fabric with precious handicraft and a romantic motif demonstrated McQueen's unique gift for elevating everyday reality.

The dress inspired McQueen's musing on flowers was a nude base with a vaulted hem and heavy bundles of real and silk roses, blue hydrangea and violets expanding across the skirt, bodice and neckline. The flowers appeared to overtake the model, leaving her arms and ankles peeking out, creating a poetic spectral vision. The interplay between fallen, faded blossoms and immortal ones was amplified by the garment's sense of uncontrollable, wild growth. Beautiful but feral, the dress was constructed to appear beyond humanity's control.

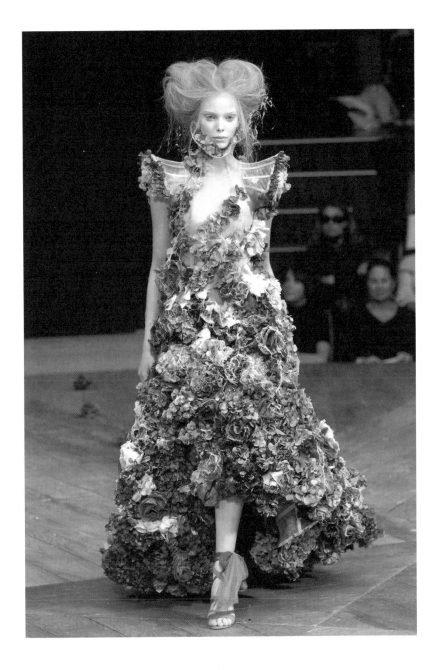

Find the **Darkness**

McQueen managed to popularise his fixation with life's ephemerality and make profundity mainstream with his ubiquitous skull scarves. He is best known for museum-worthy catwalk creations but his accessories typified the early years of the twenty-first century, with his skull scarves becoming among the aughts' most iconic items. In an era between the AIDS epidemic, the opioid epidemic and COVID pandemic, consciousness about mortality, grief and loss felt distant in the cultural imagination. McQueen's scarves were as much a visual reminder of profound realities as a trendy, 'edgy' symbol celebrating a decadent rock-chick life-style. Although many fans of the scarves seemed detached from their symbolic significance, McQueen was aware of their power.

These coveted scarves were made from thin, almost translucent silk. The scarves remain classy with delicately frayed edges and a collection of differently sized skulls with a series of stripes or smaller skulls inside a border. The impact resembles artwork within a frame. Throughout its many iterations, the material and print remained consistent. The colours ranged from white, pink or black skulls against black, red, pale pink or white backgrounds. McQueen's label was written large in one corner and was very visible in the scarves' tail when worn draped or open.

Kate Moss became its most recognisable acolyte; she wore her monochrome version consistently throughout the century's first decade, either loose around her neck or tied tightly as a belt for skinny jeans. In recent years, her little sister, Lottie, appears to have inherited the scarf or its twin, wearing it in several nostalgic street-style looks.

→ Skull prints, like those wore by Kate Moss on his catwalk, were McQueen's principal contribution to mainstream and high-fashion iconography.

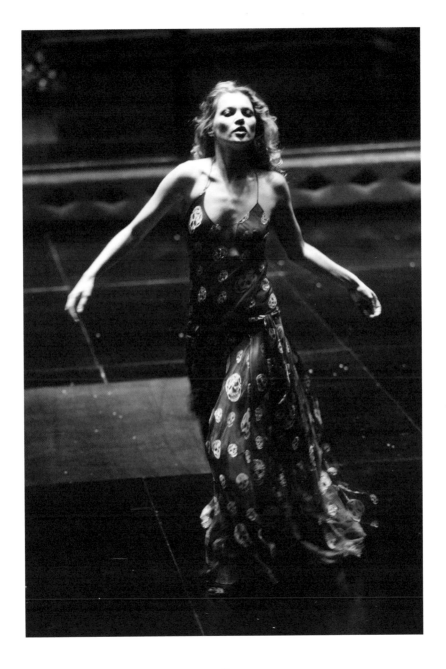

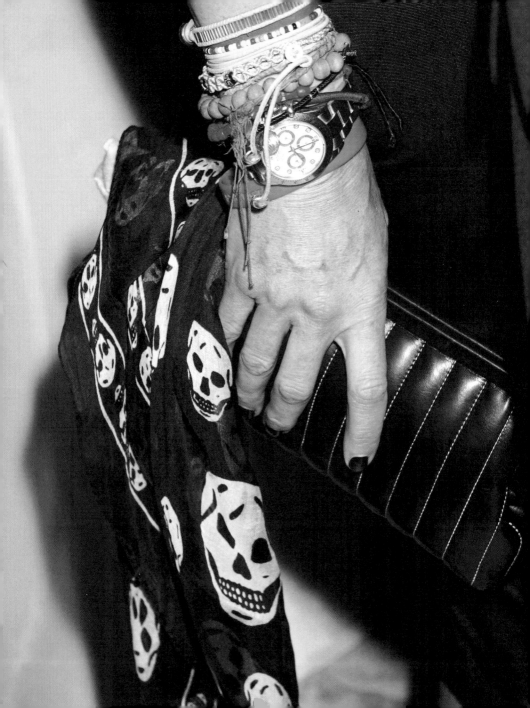

"It is important to look at death because it is a part of life. It is a sad thing, melancholy but romantic at the same time. It is the end of a cycle ..."

McQueen

Other celebrities of the time, such as Sienna Miller, were routinely seen with the long, diaphanous, distinctive scarf casually worn with leggings, jeans or mini dresses. It was wound around bag handles or women's hair but was usually draped very lightly around necks, so the long ends dangled down to the thighs. The look radiated insouciance and gave trivial tabloid personalities a hint of depth, as they flaunted a cool connection with existential reality and the omnipresence of mortality in everyday life. According to McQueen, 'It is important to look at death because it is a part of life. It is a sad thing, melancholy but romantic at the same time. It is the end of a cycle ...'

The skull scarf was first seen in McQueen's Spring-Summer 2003 collection. Allegedly inspired by shipwrecks and pirates in Roland Joffé's 1986 film *The Mission*, the print positioned the morbid motif against tissue-thin material. The film's narrative of a Jesuit priest on a mission in eighteenth-century South America provided heavy subject-matter that was juxtaposed with a light fabric: with a light fabric and demonstrated McQueen's perspective on life's transitory nature and death's constant presence.

← Silk skull scarves were a defining symbol of the noughties and remain constantly in production — becoming the subcultural answer to the upper-crust Hermes scarf.

Celebrate your Identity

McQueen threaded his personal history throughout his oeuvre with tartan as a *leitmotif*. He used tartan for both its bold, complex look and its significance against the English establishment. For McQueen, the visually and conceptually strong fabric was a signifier to evoke his own family's Scottish ancestry, the country's fraught political history and the interplay between his painful early experiences and his heritage.

Lochcarron, the foremost tartan weaver, replicated the McQueen clan's red, green and yellow plaid for the designer's collections. McQueen used impersonal plaids at points in his career but his clan's tartan was a signature, almost a Hitchcockian way of explicitly bringing himself into his work.

→ A nude silk top with lace applique was worn under an asymmetrical dress of McQueen's family tartan, modernizing his heritage and historical awareness.

As the designer stated, 'I like things to be modern and still have a bit of tradition.' When he created loose trousers with a grey/moss-colored tartan for his Autumn-Winter 1999–2000 *The Overlook* collection or body-hugging dresses in candy-coloured checks for his Autumn-Winter 2005–6 *The Man Who Knew Too Much*, McQueen was creating characters in an objective narrative. When his collections included his own family tartan then McQueen was present.

He had multiple motives for incorporating tartan into his work, including a direct opposition to Vivienne Westwood's romantic appropriation of the problematic plaid. As London's forerunning provocateur, Westwood was a strategic figure to confront, but McQueen also had authentic reason to be offended by her disingenuous cultural appropriation of tartan as an iconic British fabric. Early in his career, McQueen fought to reclaim tartan and draw attention to its history. When McQueen first presented tartan, in his fourth show, the

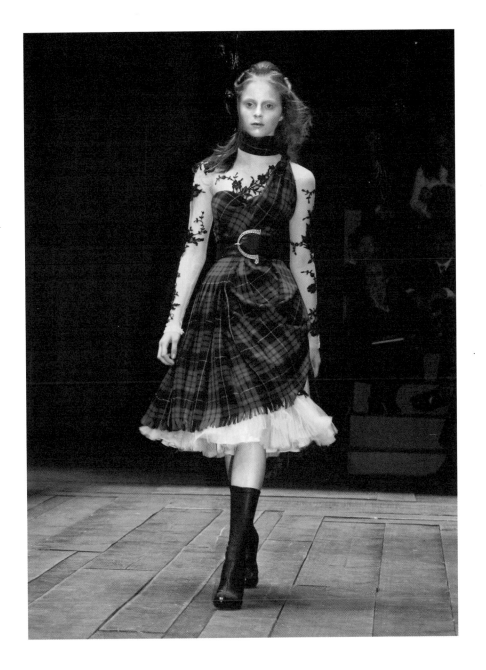

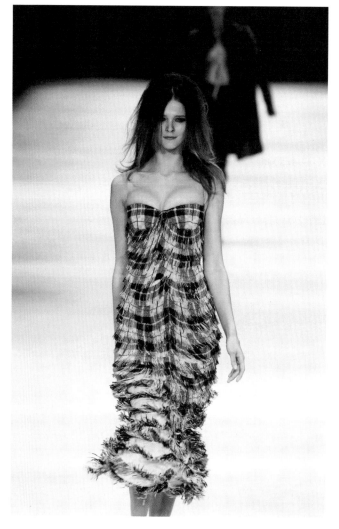

↑ Combining his tailoring training
and reference to his Scottish
heritage, McQueen merged the
key aspects of his craftsmanship
and creative identity.

← McQueen said 'the reason
I am patriotic about Scotland is
because I think it's been dealt a
really hard hand.' He revitalized
tartan, the symbol of Scotland,
to signify his affinity with his
heritage's vibrancy and struggles.

"I like things to be modern and still have a bit of tradition."

McQueen

Hollywood film *Braveheart* was a cinema blockbuster, popularising a mythic version of Scottish independence.

McQueen introduced his family's accessorial tartan in his Autumn-Winter 1995–96 *Highland Rape* collection to connect his vision of resilient survivors with the 'ethnic cleansing' of the Scottish Highlands by nineteenth-century British profiteers. His show's work and title referred to the Highland Clearances, when crofters were forced off their land. For the show, McQueen covered the catwalk in heather and bracken, sending the models running in torn and tattered jackets and bodices lined with decimated lace. He cut the checks on the bias, carefully aligning the patterns to complement forms and styles borrowed from BDSM style and club wear. The models appeared battered but fierce. The show elicited ferocious criticism from critics who interpreted misogyny as a motive but McQueen was adamant that his women were victorious in the face of adversity – and he saw himself in them. Tartan, the primary fabric, alongside with lace and latex, highlighted McQueen's sense of passionate identification with his heritage.

The
Inspiration

Always Listen to Mother

Joyce was more than Alexander McQueen's mother. She was his soulmate, guide and muse. When McQueen was a child, she taught him the intricacies of his family's fraught and complex history. When writing his biography of the designer, Andrew Wilson described McQueen listening to Joyce's stories of 'violence, poverty and fragmentation, a triumvirate that continued to shape the family for the next couple of centuries' and hearing evidence of resilience and rebellion. Murder and tragedy were common themes in McQueen's legacy, threaded from Scotland to London. Joyce, a social science teacher who taught genealogy, was born in Hackney but traced her roots to the Huguenots of Spitalfields.

→ McQueen's historical references turned away from glossy romanticization of the past towards a more nuanced, gritty, raw, exploration of his own heritage and cultural complexity.

McQueen's identity was intensely connected to his ancestry and family history, which he learned through his mother.

When McQueen was a child, his father, Ronald, was institutionalized. While Joyce was, in practice, a single parent, she lavished her son with love and attention. Their bond was tight and especially profound. McQueen credits his mother with his original move towards fashion. She saw a report on television about a shortage of tailors at Saville Row and encouraged McQueen to apply.

The stories of poverty and horror, especially regarding the proximity of the family home to the territory where Jack the Ripper prowled, the notorious Victorian serial killer who Joyce told her son about would influence his creative imagination throughout his career. McQueen's work was always fresh and contemporary, because of, not despite, a fixation with the past and his own history. One of his great gifts was bridging era-specific references, particularly

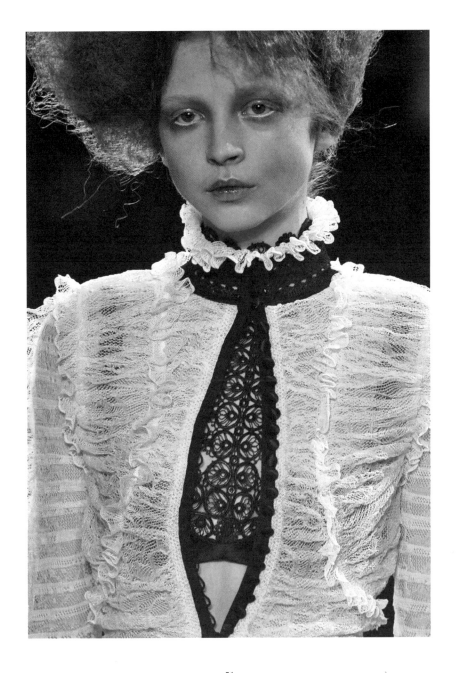

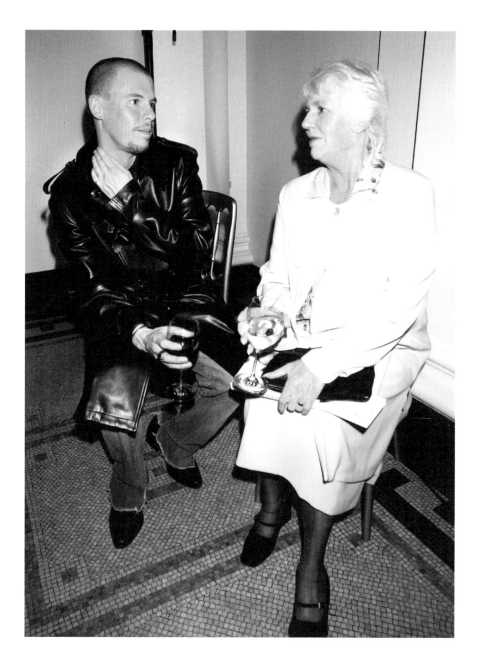

"'What is your most terrifying fear?' Alexander McQueen: 'Dying before you do?'"

The Guardian

those from the Victorian age, with current sensibilities. This form of post-modern pastiche recreated the experience of a present-day listener imagining images of the past: McQueen's garments told the story of himself connecting with his history. Joyce encouraged and appreciated her son's

← Joyce McQueen (1934–2010) was McQueen's best friend, champion and ultimate muse. Her influence on his wit, creativity and character remained prominent throughout his life.

transgressions, toughness and creative risks. McQueen's success was a great source of pride to her but his integrity mattered most. They bantered and shared great respect and playfulness with each other.

In 2004, Joyce interviewed her son for *The Guardian*. She asked him, 'What is your most terrifying fear?', to which he responded, 'Dying before you do.' She replied, 'Thank you, son.' Whether McQueen was alluding to being HIV-positive or his omnipresent preoccupation with his own death in this statement, Joyce seemed to understand and accept his fear. His existential bond with her transcended their physical or psychological states. She died at age 75; he took his life almost a week later.

Know your History

As a master of pastiche, McQueen combined references to disparate eras in his concepts, tailoring and presentation. A formative influence on his craft was *Libro de Geometria, Práctica y Traça*, a sixteenth-century book of patterns ascribed to the tailor Juan de Alcega. The cuts detailed in the book were seen in McQueen's Autumn-Winter 1996–97 *Dante* and Spring-Summer 2009 *Natural Dis-Tinction Un-natural Selection* collections.

McQueen's greatest homage was of a more personal nature, found in his repeated referencing of his own family history. He became known as the 'hooligan of English fashion' for his refusal to suppress the rougher aspects of his background,

→ When reflecting on her astonishing career, Erin O'Connor told Vogue magazine that her appearance in McQueen's Voss show, wearing red-painted medical slides and ostrich feathers, was 'probably the most exciting show I've ever done.'

instead celebrating them. Scotland and London's East End were perennial sources of inspiration. His Spring-Summer 2007 *Sarabande* collection borrowed techniques and images from the time when McQueen's ancestors lived near the main fashion district — where street crime, poverty and violence rubbed against laces and luxe textiles.

In the 1850s, McQueen's maternal ancestors lived on Dorset Street, an area that Jack the Ripper made eternally infamous by murdering and mutilating sex workers in the 1880s. McQueen took his childhood fixation on Jack the Ripper as inspiration for his first show in 1992 where he honoured the lives of the women through distressing calico to replicate their stressed clothes and included references to their complex lives in his designs. McQueen meticulously researched the period in order to reference norms and aspects of the past, while creating a link to himself as a survivor of childhood trauma — transcending, but also retaining a history of horror.

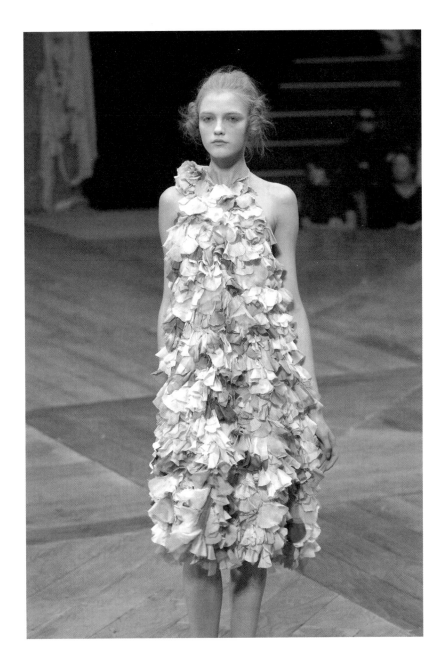

Find the Devil in Details

McQueen and his mother, according to biographical accounts, were watching television together when they saw a report lamenting the death of traditional men's tailoring and the dearth of skilled apprentices. Joyce encouraged her son to train on Savile Row and the skills he quickly and masterfully acquired there remained hallmarks of his career. McQueen's clothes had a massive cultural impact not just for their conceptual heft but for their textual and aesthetic achievements, his technical gifts almost unmatched by his peers during his lifetime. He had an uncanny ability to cut and fit fabric to a body, and Savile Row was where he learned the relationship between textiles and flesh.

→ McQueen played to his history training on Saville Row by using classic menswear materials and cuts to spotlight the archetypical feminine form.

When McQueen started, he worked at Anderson & Sheppard. One of Mayfair's oldest tailors, they had been outfitting gentlemen since 1906. Their signature suits were graceful and gracious, moving easily with their wearer while retaining a traditional aesthetic. In its heyday, Anderson & Sheppard dressed Fred Astaire, Cole Porter and other male stars known for their elegance and sophistication. They overlooked gender transgression and famously commented 'ladies are welcome, provided they w[ear] men's suits'. Marlene Dietrich was a client.

As a seventeen-year-old apprentice, McQueen's annual salary was less than the cost of a few Anderson & Sheppard suits but he learned how to cut, switch, line and detail a jacket. He commented that working at Anderson & Sheppard, 'was like Dickens, sitting cross-legged on a bench and padding lapels and sewing all day – it was nice.'

The structure and ritual involved in creating an esteemed suit was compelling for

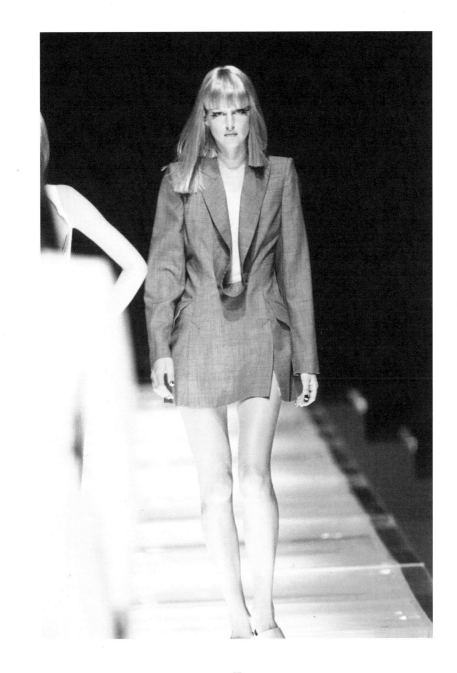

"[Anderson & Sheppard] was like Dickens, sitting cross-legged on a bench and padding lapels and sewing all day."

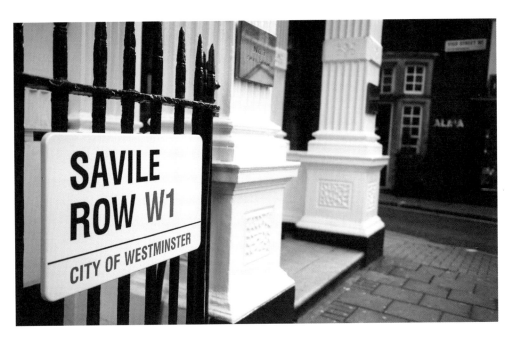

McQueen when he moved towards crafting garments worn by women. A black wool mini dress from his Spring-Summer 1998 collection demonstrated the impact of his training on Savile Row, its precise replica of a man's suit recreated for a woman's body. The skirt, skimming the thighs, has small vents like the back of a man's jacket and the upper half was almost interchangeable from a man's single-breasted jacket — except it was completely open and scooped to the wearer's naval. With great subtlety, McQueen demonstrated his approach to gender constructs while creating a uniquely sculptural garment.

In 2013, the Alexander McQueen flagship store opened on Savile Row. A posthumous homage to McQueen's creative history, it was only the second time an international brand occupied the street known for bespoke men's tailoring. The shop's interior partially functioned as a gallery, with artworks on view, but retained traditional display cases for accessories and decorative moldings. The store's location and appearance was a delicate acknowledgement to the site of McQueen's real sartorial education.

↑ Established in 1730, the strip of tailors in Central London known as Savile Row, remains the nexus for traditional men's tailoring, setting the standard for high-end, professional menswear.

Show Skin

Skin, for McQueen, functioned as another sensual and conceptual material in his designs. Instead of using models' flesh as empty space or using fabric to frame salacious bits, he incorporated skin and erogenous zones into his garments' narratives. For him, fashion was about juxtaposing vulnerability and armour. Andrew Wilson summarises the McQueen image of the archetypical woman as 'vulnerable but strong, a survivor', women like his sister and mother. These qualities were not contrasts but interconnected for McQueen, and the delicacy of skin, alongside its resilience, was a prime motif for him.

Sex was omnipresent in McQueen's work, whether it manifested as nudity or bodies encased in haute-fetish-gear. When he first showed his bumster trousers, the point was drawing all attention to a forgotten patch of skin. The base of the spine, not just the buttocks, were erotic and compelling in McQueen's extremely low-slung trousers. He interpreted the effect as 'quite menacing' because the exposed areas of skin elongated the models' limbs and torso in contrast. The unexpected sight of hip-bones and sacrum highlighted the model's clothes, making him or her appear more dressed than they were with an amplified centre line.

When McQueen created his 1997 homage to the disquieting work of surrealist Hans Bellmer, he was recreating the mood and sensibility of entirely naked dolls by using pink fabric and beaded fringe. In one look, model Stella Tennant wore pink trousers, cut to appear spliced at the crotch, over a black bodysuit with a small slash. A tiny slice of her skin was exposed, behind a zip, but the rest of her torso was covered. That hint of sensitive skin alluded to Bellmer's bizarrely

→ Vast sections of exposed skin, like Rosemary Ferguson's bare bodice in his HG Wells-inspired 1997 collection, signified women's vulnerability and power.

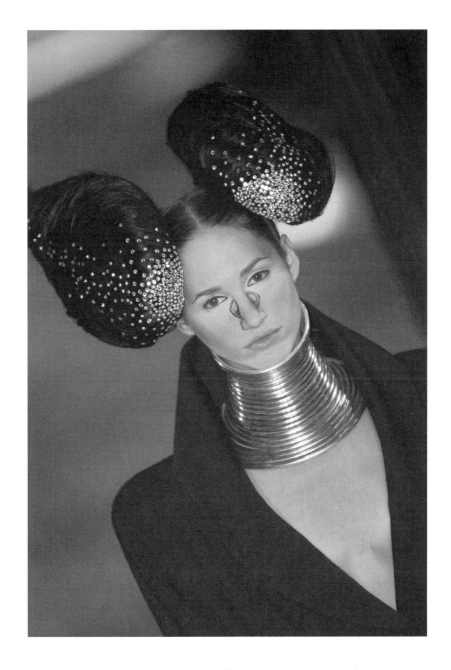

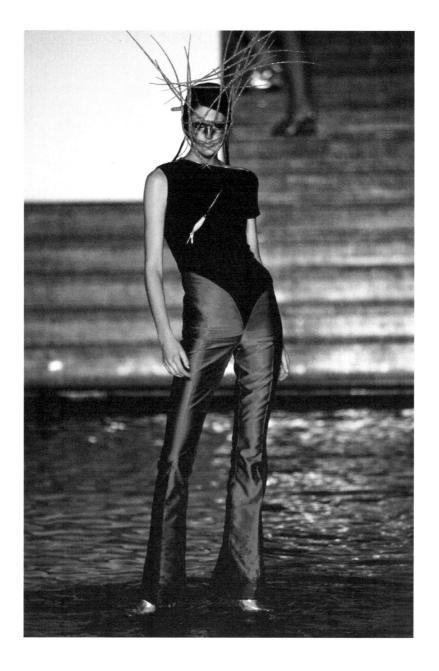

"I want to empower women.
I want people to be afraid
of the people I dress."

McQueen

contorted and mutilated dolls, whereas Tennant's bare carried little erotic heft.

For his Autumn-Winter 1997–98 *Eclect Dissect* show, he sought inspiration from the horror story *The Island of Doctor Moreau* by HG Wells, and presented Rosemary Ferguson in thick black velvet, a dense metal coil around her neck, her bodice leaving her breasts visible from the side. Her exposed sternum, under the metal Burmese Kayan neck-brace, appeared especially vulnerable but her posture was bold, strong and defiant. The resounding strength articulated in this look would have been muted if she had worn anything underneath her jacket. Instead, her bare skin made the more blatantly commanding materials McQueen used have

poignancy and immediacy – humanising their intensity. When McQueen chose to show breasts, you could feel the very heartbeat beneath them. As he said, 'I want to empower women. I want people to be afraid of the people I dress.'

← The smallest splice of Stella Tennant's torso seen in this 1997 zipped stop amplifies the garment's intensity and connection with the wearer's body.

Find **Kindred Spirits**

'Lee was drawn to people who were wounded,' Daphne Guinness, one of his main muses, said about McQueen. Throughout his time in fashion, he forged friendships with beautiful, complex, poetic women who influenced his designs. McQueen had an innate and powerful ability to connect deeply with people's vulnerabilities and speak directly to their core. His own history of traumas, as a survivor of childhood sexual abuse and witness to domestic violence, heightened his sensitivity to others' suffering. By connecting with another person's pain and power, McQueen revived the concept of a 'muse', a role dismissed by feminist analysis as parasitic or stifling. Instead of objectifying their personas, McQueen paid homage to the essence of the women who embodied his vision of female strength and fragility.

→ Daphne Guinness described
a core component of her bond
with McQueen as their shared
'comfort embracing chaos'.

McQueen's friendship was notoriously challenging but uniquely fulfilling. After his death, his known best friend, Annabelle Neilson told reporters, 'He's the one person I would probably forgive anything. Maybe you forgive difficult people more.' McQueen and Neilson's bond transcended all the gaps between them; they became like soulmates. She reported finding his energy 'magnetic' and he cherished her rebelliousness, defiance and difference.

Guinness was a kindred creature. Her beauty and apparent fragility contributed to their collaborative artistic expression. When she was a child, already deeply imaginative and haunted, she was the victim of an attack by a family friend. From this mix of horror and luxury, she connected with McQueen and their collaborations became fusions of their lived experiences, visions, aspirations and aesthetics. When McQueen designed his Oyster dress for Guinness to wear, he realised her ethereal identity in all its complexity – ravished but transcendent.

Forge Tight
Bonds

McQueen forged bonds with his muses through a shared understanding and coping with suffering but his connection with Isabella Blow, arguably his most complex relationship, was strongest because he made her suffer. The sexual tensions and dynamics that McQueen evoked through his BDSM-inspired designs, were more raw and messy in his relationship with Blow. Their mercurial connection was predicated on shifting power imbalances but Blow's openness to extremes constantly pushed McQueen's boundaries and nurtured his genius. She was his tireless ambassador.

Blow was McQueen's first patron and guide into fashion's upper echelons. She bought his entire first collection for £5,000,

→ Isabella Blow (1958–2007) was largely responsible for bringing McQueen, Philip Treacy (whose hats she almost always wore) and a community of irreverent, unique, boundary-breaking beauty into the wider world.

paid in £100 instalments, because of its 'sense of flesh and blood'. Their competitive vulgarity and provocation became currency for a friendship in which cruelty was fun and intoxicating, until, that is, Blow's almost addictive need for McQueen's attention repelled him.

Even before meeting McQueen, Blow turned her insecurities into her strengths. Hyper-aware of her unconventional looks throughout her life, Blow dressed with surreal audacity — turning herself into the vehicle for artistic extremes. As a brilliant, quick-witted visionary, Blow spotted overlooked, era-defining talent. Her mother left when Blow was fourteen and her brother drowned in the family's swimming pool as a toddler. She was born into luxury but rejected by her father, from whom she inherited only £5000 from an allegedly million-pound estate, the same sum she paid for *Jack the Ripper Stalks His Victims*. Blow entered the London fashion scene after working odd jobs and studying Chinese art

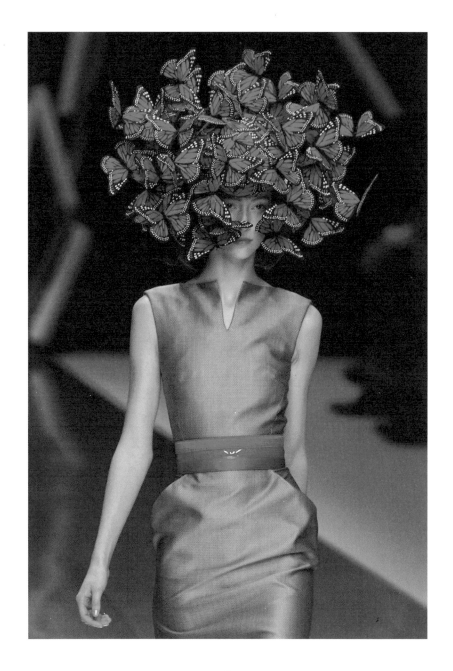

"Alexander the Great"

Isabella Blow's pet name for McQueen

history at Columbia University in New York. When she returned to London, she began working as a stylist for *The Sunday Times*, where she championed esoteric talent. Her ability to nurture artists with otherworldly perspectives gave the fashion community Philip Treacy, Sophie Dahl, Stella Tennant and McQueen.

Blow adopted McQueen as her principal cause after seeing his first show, putting all her pull into rallying support for his work. While most of his friends called him Lee, Blow insisted on calling him Alexander as she felt it suited him. 'Alexander the Great' was her pet name for him. As his fame and influence grew, McQueen started pushing away from Blow. Her patronage brought McQueen to a certain level, which he exceeded, and she

reportedly expected more loyalty than he was willing to give her. The psycho-sexual undercurrent to their relationship tipped into emotional abuse when she felt abandoned by him. When Blow committed suicide in 2007 by drinking the same herbicide that her husband's father used to commit suicide, McQueen appeared broken by the loss of an interlocked spirit. He dedicated his subsequent show to her. It was titled *Dante*.

← Blow's influence and image are evidenced throughout McQueen's oeuvre, in looks like this Treacy butterfly hat hovering over curves resembling her famously feminine hourglass form.

Don't Be Scared of Fear

McQueen shared a fixation with the masters of horror cinema, literature and art for abjection juxtaposed with beauty. He preferred to repel than just attract. He wanted his designs to be difficult, even disturbing, so they triggered unrestrained emotions in his audiences. He knew that unsettling his viewers meant his designs cut through the surface. As he famously said, 'there is blood beneath every layer of skin.'

Alfred Hitchcock himself downplayed the horror genre by saying 'fear is not so difficult to understand' but the mechanisms creating fright offer infinitely complex insights into individuals and culture. As a fan of Hitchcock's work, McQueen recognised horror's profundity and power,

→ From the start of his career, McQueen found energy and inspiration in humanity's darkest drives, demonstrated by the bloody handprints on an otherwise pristine shirt in his 1996 collection.

celebrating its most sophisticated and complex representation. Whether he turned to schlock or camp at home, the gore he let seep onto his catwalk was sophisticated, nuanced, intellectually challenging and aesthetically refined. McQueen used colour, form and direct references to true crime or fictional horror to tap into peoples' private and collective emotional secrets.

Perfume: The Story of a Murderer by Patrick Süskind was one of McQueen's favourite books. Also referenced by Kurt Cobain in the song 'Senseless Apprentice', the 1985 novel told the story of a young man whose extraordinary sense of smell elevated him from poverty and obscurity while also driving him to murder young women. The paradox of exceptionality was a tragic parallel for McQueen's own tormented genius. The book's influence was evident in his collection *Jack the Ripper Stalks His Victims*, where a pink translucent coat, lined with human hair, references specific scenes in Süskind's visually evocative novel.

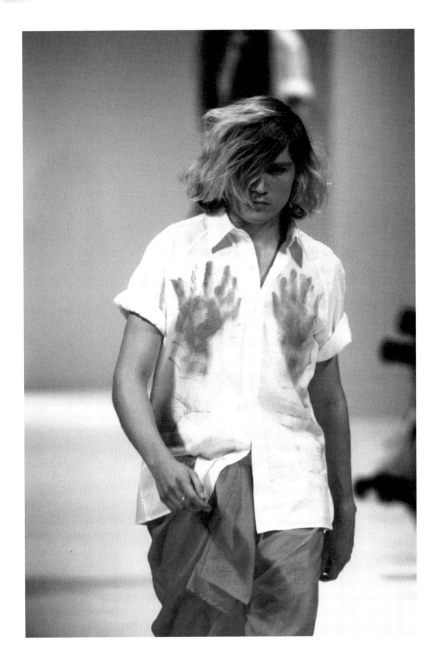

"I am about what goes through people's minds, the stuff that people don't want to admit or face up to."

McQueen

When McQueen launched his Summer/Spring 1996 collection *The Hunger*, based on Tony Scott's 1983 vampire movie, the 'undead' were the zeitgeist. He created a transparent, moulded breastplate, with worms pressed between layers of plastic, to evoke a rotting corpse, and burned the centre of a sheer dress. In Scott's elegant, urbane film, David Bowie, Susan Sarandon and Catherine Deneuve play vampires consumed by intertwined forms of lust. In

McQueen's rendition, models wearing pencil skirts and patent leather were more overtly defiant and debased. Their look was both intimidating and unnerving. Fear was more pronounced in McQueen's 2009–10 homage to Leigh Bowery's grotesque performance art – tapping into cultural anxieties about the sudden global recession. 'I am', McQueen reportedly said, 'about what goes through people's minds, the stuff that people don't want to admit or face up to.'

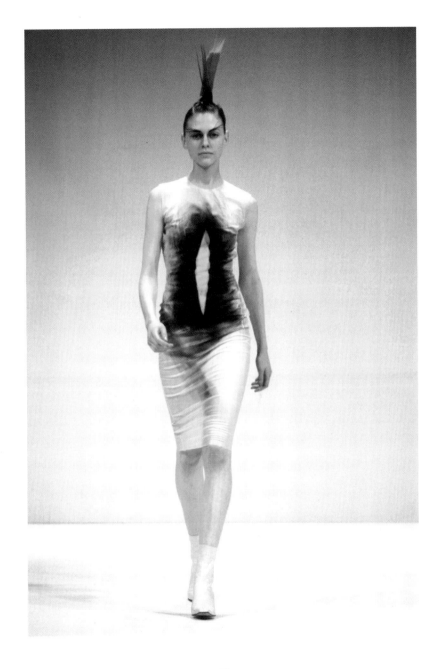

Capture the Spirit of the Times

McQueen brought the raw, rough and irreverent sensibility that made British art dominant the nineties and noughties into fashion. His closest peers were the artists known collectively as the YBAs. Moving to Hoxton in 1995, McQueen joined artists who combined ribald humour, defiance and ambition. Death, sex, gender and class were key themes in the YBA's collective oeuvre – and, indeed, in McQueen's career. When journalist Suzy Menkes reviewed the fledgling designer's Gothic sensibility, she focused on his synchronicity with contemporary artists and writers, remarking that he 'captured the spirit of the times'.

One of McQueen's close female friends and muses was Sam Taylor-Wood, a photographer and filmmaker whose work explored cultural value, celebrity culture and pop culture and crossed between disciplines. The 1990s were an era when 'art meets fashion' became a desirable topic for academic, critical and curatorial discussion. McQueen frequented galleries and built his personal collection, Taylor-Wood's work among it, reflecting his own darker interests. There was a sculpture from the sixties of a woman in lingerie, on all fours, balancing a tabletop on her back and a 1434 Jan van Eyck, which provided inspiration for some of the textiles in McQueen's *Dante* collection. The contemporary work the designer owned was particularly morose, combining pain and pathos with a patina of success, as befitted his own creative compass.

As McQueen's work came to be commercially rewarded and his cross-cultural prominence grew, he became vulnerable to critiques similar to those received by his YBA peers. A boundless intellectual curiosity and gift for self-deprecation kept him from becoming a creative hack while some of art's biggest names became cartoons of themselves.

→ Artist Sam Taylor-Wood and McQueen both straddled the worlds of art and fashion.

Find **Beauty**
in **Art**

When the Metropolitan Museum of Art staged *Alexander McQueen: Savage Beauty* in 2011, the exhibition brought his work full circle. Display cases presenting McQueen's masterworks as art highlighted their roots in artistic legacy and contemporary discourse. Alongside John Galliano and Martin Margiela, McQueen had established a new bond between conceptual art, theatre and the kind of fashion that turned clothes into living sculpture.

McQueen's most celebrated homage to art was his Spring-Summer 1999 *Action Painting* executed by former ballet-dancer Shalom Harlow and including paint-shooting robots. In spraying acid-green and black paint onto a ballooning white tulle dress,

→ Joel-Peter Witkin's 1984 *Self-Portrait* was the direct inspiration for masks worn by models in McQueen's Autumn-Winter 1996-97 collection.

while Harlow moved with expressive grace and movement, McQueen revived the energy of Jackson Pollock's abstract paintings for a new era. He borrowed from Rebecca Horn's 1991 *High Moon* 'machine installation'. He even replicated Joel-Peter Witkin's 1984 Christ-adorned mask for his *Dante* collection.

The relationship between McQueen's work and art ran deeper than surface referents in some instances. He used and engaged in conceptual issues at art's core. He commented, 'For people who know McQueen, there's always an underlying message. It's usually only the intellectual ones who understand what it is in what I do.'

For his Autumn-Winter 1996–97 show, *Dante*, he culled references from Flemish fourteenth- and fifteenth-century paintings for prints and cuts, joining them with imagery directly appropriated from British photojournalist Don McCullin. By taking imagery from cultural and art history, McQueen was making a strong visual

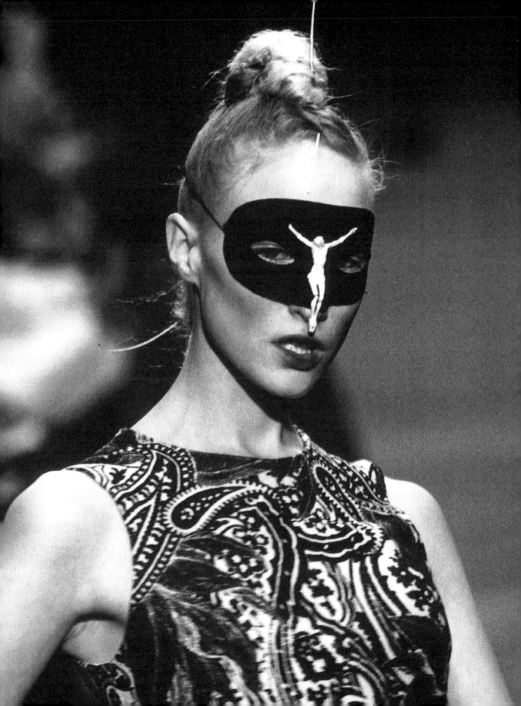

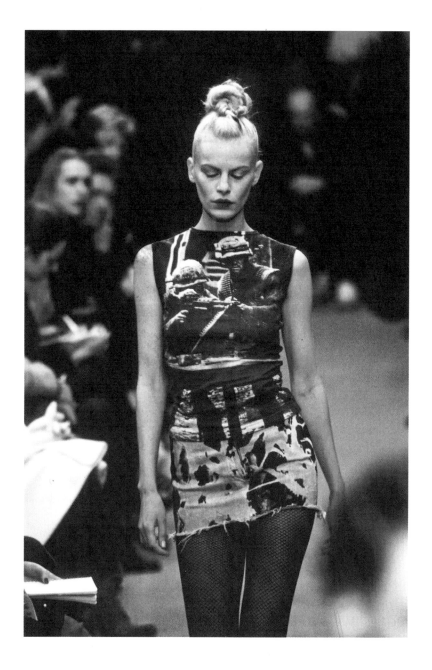

> ## "For people who know McQueen, there's always an underlying message. It's usually only the intellectual ones who understand what it is in what I do."
>
> **McQueen**

statement about depictions of violence while involving fashion in a heated ongoing debate in contemporary art about ownership and boundaries. The ethics of his appropriation remain thought-provoking, although McQueen and McCullin ultimately became friends after the former incorporated McCullin's work into his designs. Despite McCullin's retroactive approval, McQueen's unauthorised use of the photographs from Vietnam as print for the fabric for coats and jackets arguably added to the discourse about intellectual property and artists' free use of pre-existing visual material for fresh creative purposes. Appropriation and pastiche as central devices in post-modern art's toolkit were especially controversial in the nineties when artists like Jeff Koons, Damien Hirst and and Richard Prince created careers around claiming non-

art imagery as their creative property. McQueen's use of McCullin's photographs of soldiers brought to mind Andy Warhol's silk-screens of car crashes and an electric chair. Turning images of horror and suffering into prints gave them fresh life, which was appropriation art's central purpose. Instead of just going into a museum and replicating artwork, McQueen's acts of homage brought clothes into the most current, heated and meaningful aspects of contemporary art's relationship with reality and history and of making sense of the present moment.

← Jackets and dresses were printed with photojournalistic images of Vietnam by Don McCullin for McQueen's *Dante* collection.

Learn from
Animal Guides

When Anna Wintour eulogised McQueen at his funeral, she spoke of Lee sitting on his rooftop as a child, watching birds flying above him and resting on their East End perches. Birdwatching was a formative fixation of McQueen – both for escapism and as a route to understanding the world. As an adult, McQueen became obsessed with falcons and the massive leather gloves needed for protection from the birds' claws. As a result, bird imagery and elements of nature's violent beauty became constants in his oeuvre.

In 1995, McQueen paid homage to Alfred Hitchcock's shared sensibility and horrifying vision for *The Birds*. The confluence of human and natural influences in Hitchcock's movie spoke to McQueen, who replicated the prim costumes with feathers and silhouettes

→ In his 2001 *Voss* show, taxidermized birds-of-prey appeared to pick apart the model's gossamer gown while becoming extensions of herself.

of swooping birds. The show also included dresses with tyre-marks, referencing the characters' final, fraught attempts to escape irrational nature. Appearing like the ghost of roadkill, with tyre tracks across sheer bodycon dresses, the models symbolised the struggle to survive.

Mythic birds featured in McQueen's work. His bestiary included a coat of gold duck feathers in 2010, with a blossoming white underskirt, evoking Zeus's *The Aetos Dios*. More recognisable birds featured in his earlier 2001 *Voss* collection in which three taxidermied hawks held up grey silk drapery falling into a full skirt of ostrich feathers. A headdress comprising of taxidermied hawks' wings, surrounding a nest holding bluebird eggs, summarised McQueen's interest in nature's beautiful injustice.

Bestial urges for blood and raw survival tethered McQueen's narratives to reality. For him, animals that evoke fear or repulsion were compelling metaphors for hidden parts of the human experience.

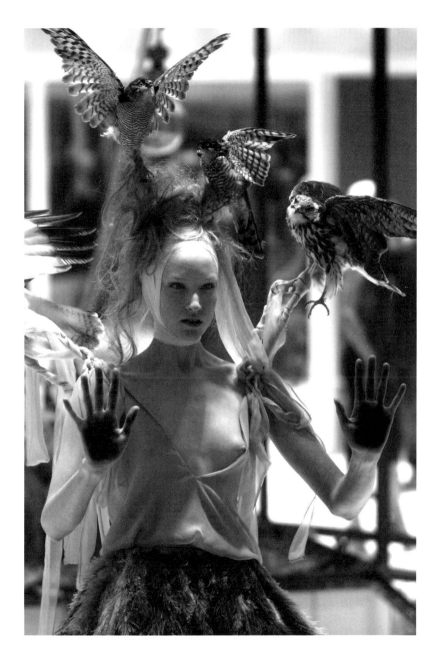

Find **Inspiration** in the **Perverse**

Beyond being coveted, McQueen's clothes and accessories were objects of raw, fetishistic desire. His creations often embodied the language of paraphilia, the world of sexual arousal running parallel to conventional understandings of love and lust. McQueen incorporated aspects of BDSM, the subculture of 'bondage, discipline, dominance and submission' into garments that could easily slip from an art gallery or black-tie reception into a fetish club. The women who wore McQueen, whether expressing a sincere aspect of their essence or wanting to appear more complex than they were, looked intimidating and knowing. As he said, 'I want people to be afraid of the women I dress', but he also created for women who wanted to feel fear.

→ McQueen's fluent use of models' exposed flesh and animal skins signalled his subjective relationship with sexual subcultures.

He understood the complex interconnections between extreme emotions and courting a loss of control.

Andrew Wilson's biography recounted McQueen's formative fixation with the Marquis de Sade's 1785 *The One Hundred and Twenty Days of Sodom*, the most significant work of literature for sexual extremists. The cruelty and objectophilia in de Sade's work, which vividly described torture and murder, became omnipresent themes in McQueen's work, something fashion historian Caroline Evans described as 'repertoires of savage dominance and mastery'. The constant shift in balance between lovers, or participants in any intimate relationship, fascinated McQueen. His own understanding of love and sexuality were possibly shaped by his early traumas but he didn't pathologise his sensitivity to power imbalances, instead he celebrated their erotic potential. He created clothes and accessories that seemed to contain secrets and invitations. He welcomed women's

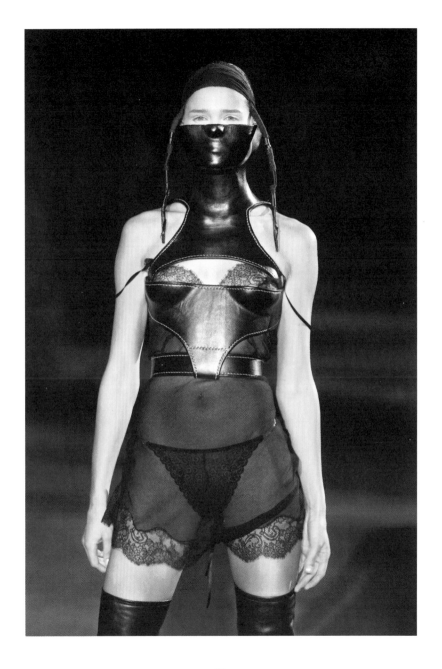

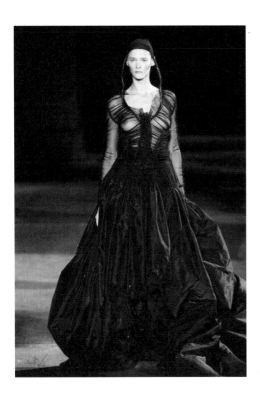

← Contrasting extreme exposure with complete coverage, this dress was worn by Gwyneth Paltrow at the 2002 Oscars, causing controversy for her comfort with her natural, apparently effortless, body and sexuality.

rawest, most voracious sexual appetites and believed everyone's sexuality had the potential for agony and ecstasy.

For Autumn-Winter 2002–3, McQueen presented a voluptuous black skirt worn with completely sheer tulle top over high black riding boots. The contrast of skin and oceans of fabric spoke to tensions between display and restraint, withholding and delivering. A leather bodice, from the same year, showcased a leather bandeau top and delicate lacerated leather lacework that would constrict the wearer's breathing like in 'breath play'. And a black leather jacket bound with straps, the ends dangling like a suspender belt against a leather skirt with a centre zip, could easily command a submissive's total devotion and adherence. When speaking of the erotic charge to his work, McQueen said 'there has to be a perverseness to the clothes. There is a hidden agenda in the fragility of romance.'

"There has to be a perverseness to the clothes. There is a hidden agenda in the fragility of romance."

Keep the
End in Sight

The power of *memento mori*, as a genre in art, is its irony. Artists create work that outlives them. When an artwork is appreciated, valued and preserved then it can last through generations and contribute to people across their life-spans for decades or centuries. The strange importance of *memento mori* is doing viewers this profound service while depicting death and decay. The purpose of the genre, with its own everlasting relevance and tradition, is reminding people that we are mortal and life cannot be taken for granted. As an artist with an endless interest in death, decay and the quest for life's meaning, McQueen gravitated towards imagery and process that either evoked this genre or explicitly joined it. He either referenced the standard images

→ Iridescent Armadillo Heels, carved from wood and averaging 30cm, from McQueen's 2010 *Plato's Atlantis* transform models into supernatural visions – like humans returned to nature.

from *memento mori* art in his signature imagery or he created garments with an internal hourglass, where their fading beauty represented all of our waning vitality.

Musing on death was not only a central motif in McQueen's work but arguably his vision's primary purpose. He incorporated locks of human hair, sometimes his own, into the inner lining of his earliest collection as both a means of memorialising Jack the Ripper's victims and highlighting an awareness of life's ephemerality. This practice was part of a Victorian tradition, with an ongoing niche following. Including hair in small plastic packets underneath his label evoked the Victorian trend for rings, lockets and other keepsake items, including locks of a dead lover's or child's hair, encased in glass and framed by beautiful gold or seed pearl settings. The gold brocade-print jacket in McQueen's *Dante* collection, with its packet of human hair, resembled such a setting. 'Clothes and jewellery should be startling, individual,' he once said.

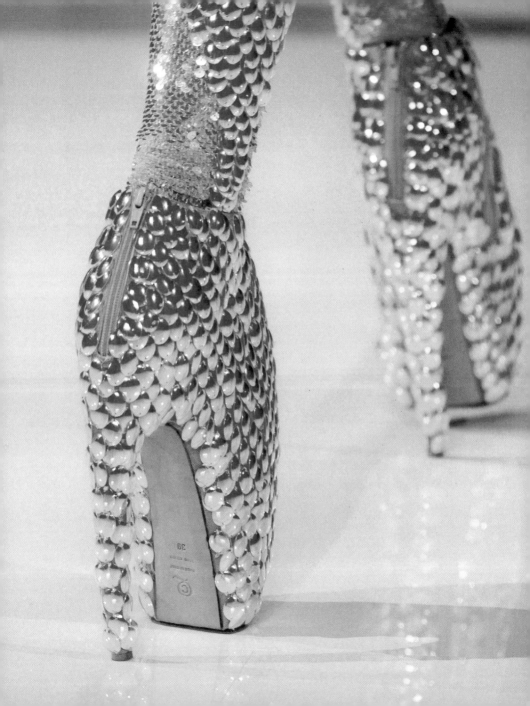

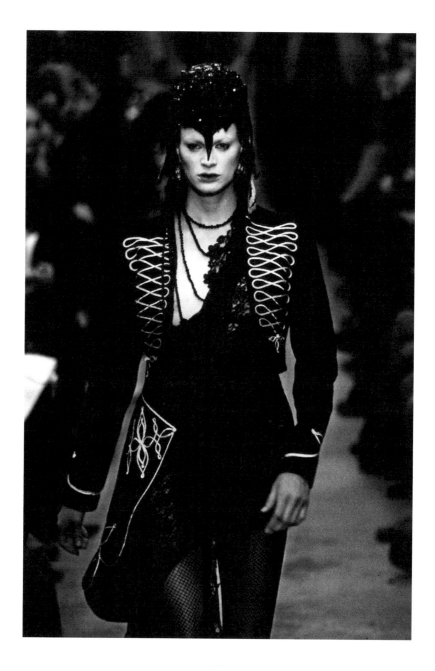

"Clothes and jewellery should be startling, individual."

McQueen

McQueen's signatures contain most of the symbolic objects found in sixteenth-century *vanitas* paintings, the genre establishing the lexicon for Western *momento mori* artwork. Skulls, butterflies, flames, flowers were all central elements in this artistic tradition – each symbolising intense but fleeting existence. McQueen was best known for his consistent use of skulls in prints, catwalk décor and accessories – for haute- or mass-market contexts. Flowers were another staple of his repertoire. For his final collection, which was shown during his lifetime, *Plato's Atlantis*, in Spring-Summer 2010, the scales on his 'jellyfish' dress, trousers and *en pointe* Armadillo shoes gleamed like soup bubbles, creating an illusion of impermanence. Seen in the context of McQueen's suicide, the show was disarmingly optimistic – commenting on Darwinian evolution and the return to life's origins in the ocean.

The
Details

Use your
Head

Among the most iconic items of the noughties, McQueen's scarves, rings and other accessories drew upon various artistic and cultural traditions, from the seventeenth-century European *memento mori* to the Mexican *calavera*, to bring an awareness of life's transience into mainstream fashion.

McQueen used knuckle dusters adorned with heavy metal-style skulls as handles for brightly coloured fabric, animal skin and hard-shelled clutches.. With jewelled eyes and baroque settings, the power of McQueen's clutches is in their contradictions. The juxtaposition of the assertive handles, with their rough

→ McQueen incorporated the skull, one of the most significant and universal symbols, into his own signature. Whether in his mass-market or haute-couture creations, skulls signified his intimate relationship with death and passion for life.

subcultural implications and opulent materials, created mystique. The bags' hard-edged intensity was heightened by the dark humour of the skulls. They were pretty but the skulls demonstrated the willingness of the wearers to go to dark places. The bags prove Marilyn Manson's adage right: 'If you act like a rock star, you'll be treated like one'.

Similarly, the simplified skulls that float on McQueen's scarves and seem to be smiling knowingly hark back to the Mexican folk art tradition celebrating *Día de los Muertos* or the *Day of the Dead*. The tradition, known as *calavera*, dates back to the fifteenth century and includes *calaveras de azúcar*, decorative sugar skulls. With glittering smiles and joyful colours, these sugar skulls represent rebirth rather than grief. Made from pressed and painted sugar, they are ephemeral and sweet but resilient.

McQueen's skulls served a similar conceptual purpose, although his monochrome designs create a different impression to the bombastic energy and

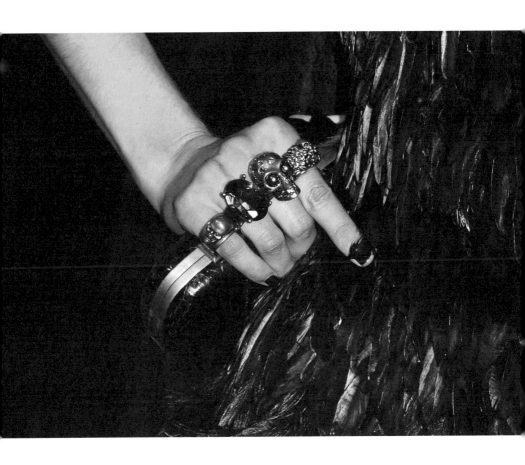

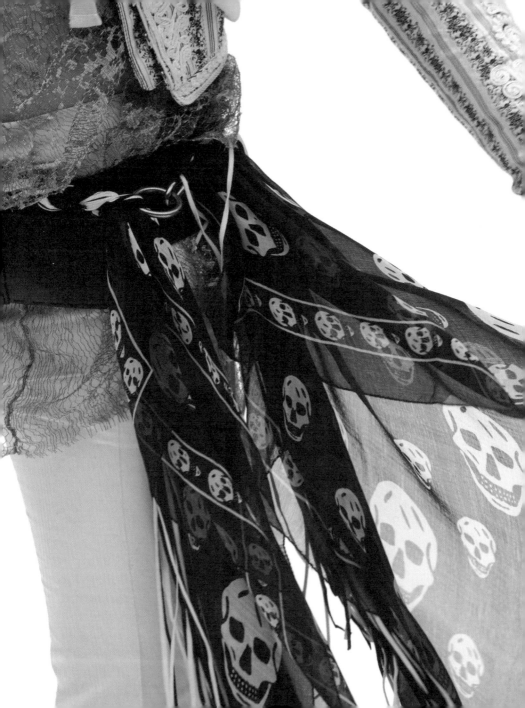

"If you act like a rock star, you'll be treated like one."

Marilyn Manson

intensity of Mexican folk art. The stark contrast of McQueen's skulls against a single-coloured background alludes to *calavera* while also evoking Andy Warhol's no-nonsense silk screens. Direct, streamlined and easily replicated, the scarves garnered a cult-like following because of their wearability. The silk McQueen used to produce his long, slinky, very fragile, but multifaceted scarves was thin and sheer. Whether black, red, pink or white, the colour on which various-sized skulls seemed to float was semi-transparent, almost a gauze. Easily layered over blazers or blouses, worn with jeans or leather leggings and smoothly incorporated into professional or street-style, the scarves' cut and pattern

was subversively simple and effortlessly cool. With a different pattern, the scarves' material might seem flimsy but the contrast of soft, light fabric and a poignant theme gave them integrity and grit. McQueen's skulls function as remembrance and reminder, bringing the dead back into life and also providing an awareness to the living that death is a constant and is coming.

← Soft, elongated, sheer and striking, McQueen's skull scarves became instant classics worn in multiple ways by top tastemakers of all genders. Their silk-weave gave the skulls a ghostly quality but also luxurious tactility. They remain widely coveted.

Find **Strength** in **Fragility**

For a material lacking the inherent
qualities that make fabric functional, lace
has historical and artistic significance,
which McQueen purposefully highlighted
and subverted. His use of lace, as a primary
material or decorative detail, drew upon
its complex role in women's history and its
compelling dichotomies. 'There is a hidden
agenda in the fragility of romance,' he said.

Lace is traditionally made from delicately
woven silk, linen or gold thread or yarn. Its
origins are traced to fifteenth-century Italy.
Needle and bobbin lace became common
in home décor and fashion by the sixteenth
century. Loops and picots adorned cuffs and
collars for women and men, including the
clergy. Catholic vestments were lace's first
entry into ceremonial garb but it achieved its
greatest significance when Queen Victoria
was married wearing lace. The Queen's
wedding dress, designed by William Dyce,
for her marriage to Prince Albert in 1840,
set the style for wedding dresses through
to the present. Her off-the-shoulder gown
still appears fresh today because it combines
visions of purity and substance. The gown
was formidable but comprised delicate,
light, opulent layers, using tiers of white
lace and silk.

Lace is often understood for its surface
delicacy – it is a strictly decorative material.
It provides no warmth and scant covering.
Its sole purpose is its beauty, yet it is not
strictly ephemeral. Museums and antique
markets possess centuries' old lace. It
is a material with great durability that is
defined by its tension between strength
and fragility. It appears extremely delicate
and yet the woven threads are resilient and
flexible. These compelling contradictions
interconnect with McQueen's core
conceptual concerns.

→ Cream resin antlers and lace,
McQueen's 2006–7 *Widows of
Culloden* gown is an ethereal
wedding dress combining delicate
and resilient materials.

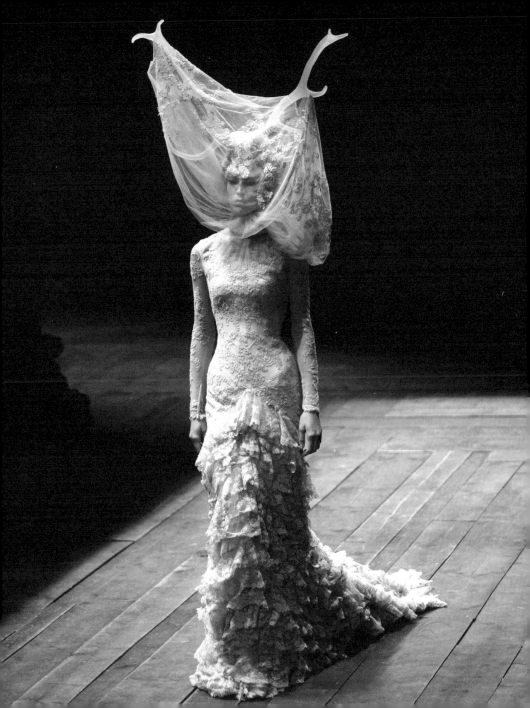

→ Lace cut to function like a second-skin attracted the attention of Isabella Blow and other editorial taste-makers in McQueen's 1995–96 *Highland Rape* collection.

For his *Highland Rape* collection, McQueen included a grey lace dress cut skin-tight with patches removed to reveal the model's skin and white G-string. The scraps of delicate floral lace peeled off her body like flaking skin, demonstrating the macabre undertones to the designer's poignant first collection. The nearly invisible material contrasted powerfully with the strong tartan shown elsewhere in the show. Later, McQueen used lace-like patterns for his iconic knuckleduster clutches, creating a striking contrast between the fierce metal and genteel fabric. A 2006 silk and lace dress, worn with resin antlers by model Rachel Zimmerman for McQueen's *Widows of Culloden* collection, spoke directly to the wedding-dress tradition. Tight on the long bodice, with lace sleeves, the dress descended into a cascade of cream lace and pale yellow silk. Light but striking, it looked ready to withstand the test of time.

"There is a hidden agenda in the fragility of romance."

Give it a
Soft Touch

Velvet's association with nobility and decadence made it ripe for McQueen's masterful touch. His consciousness combined sincere appreciation for a material's sensual delights with a constant ironic awareness of its symbolic significance and history. An opulent pair of velvet slippers with McQueen's signature embroidered skull is an accessible example of his brand's ethos — luxury with self-awareness and bite.

Throughout its history, velvet has carried connotations of rarified luxury in garments and interior décor. It is an inherently erotic and glamorous material because of its extreme softness and the richness of hue when dyed. Velvet is defined by the fabric's structure, not its fibre, with raised loops or

→ McQueen modernized velvet while retaining a close connection with the fabric's historical roots. In 2008-9, he married velvet and ivory silk tulle for his *The Girl Who Lived in a Tree* collection.

tufts. With its dense, cropped pile, velvet has a unique feel and light-reflecting shine. Made from woven tufted natural or synthetic fibres, velvet's texture replicates the delicate skin of an animal or the petals of a wild flower. When dyed, velvet acquires a deeper, more complex colour than most other materials. Blues and reds become especially sumptuous and unique in velvet.

McQueen drew upon the material's history to celebrate its intense sensuality. Believed to have been invented around 221–206 BCE in China, velvet was introduced to traders on the Silk Road in the twelfth century. In a Western context, it has been associated with ecclesiastical vestments and royalty since the Renaissance. Mechanically produced velvet was made during the Industrial Revolution for home décor and fashion. By the 1920s, velvet had become widely popular for shawls and dresses and it was a counterculture staple in the 1960s. In the eighties and nineties, the mass market turned towards crushed velvet — which is

"The world needs fantasy."

McQueen

created by twisting the original fabric under wet chemicals to produce a distinctively flexible and light-catching material.

In his collections, McQueen drew most upon velvet's optical and tactile properties, and its European legacy for pieces like the gold bullion brocade red cape in his Autumn-Winter 2008–9 *The Girl Who Lived in the Tree*. The jacket's tight fit and rich black colour evoked eighteenth-century oil paintings, demonstrating velvet's lavish heritage. Red velvet brocade sleeves grounded an explosion of ivory silk tulle for a cloud-like bodice and draped skirt in the same show. A similar skirt, worn over gold leggings, was seen with a Napoleonic black velvet jacket. Red velvet inlays on a sheer bodysuit, worn under a tartan empire-waisted dress by Natasha Poly, in 2001, looked like scars and demonstrated McQueen's unique, poetic ability to harness material to portray beauty and tragedy. As the designer said, 'The world needs fantasy.'

Go **Wild**

'Animals,' McQueen once said, 'fascinate me because you can find a force, an energy, a fear that also exists in sex.' Skins and fur were significant parts of his creations, and he was at the forefront of efforts to present transparently ethical sourcing when using real skins, and he also often incorporated animal prints into his collections.

Prints, especially leopard print, occupy strange territory in fashion's iconographic landscape. John Waters, the artist and film director known for his camp and gleeful filth, used leopard print for the cover of his book *Shock Value: A Tasteful Book About Bad Taste* because of its associations with over-the-topic glamour and wanton sexuality. In the 1950s, film stars swathed in leopard print were the femmes fatales and rebellious sexpots but the pattern also carried connotations of rarefied luxury. In the 1960s, leopard prints spanned the cultural consciousness worn by cultural icons, from Jackie Kennedy in an Oleg Cassini leopard coat to Edie Sedgwick memorialised in a Bob Dylan song for wearing a 'Leopard-Skin Pill-Box Hat'. By the seventies, leopard print had become connected with women's liberation, exemplified by paparazzi photos of Diane Von Fürstenberg wearing a leopard-print wrap-dress while chatting with Andy Warhol, but it was associated in mainstream media with predatory female sexuality.

Resistance to and embrace of leopard print are deeply connected to cultural rejection or celebration of female sexuality. Leopard print, perhaps more than most fabric patterns, is profoundly aligned with societal attitudes about sex and women's sexual agency. Cats are common symbols for female sexuality, with brothels termed 'cat houses' and common terms for cats also

→ For his Autumn-Winter 2005–6
Ready-to-Wear collection, McQueen
evoke the Hollywood glamour
and sexuality of leopard print.

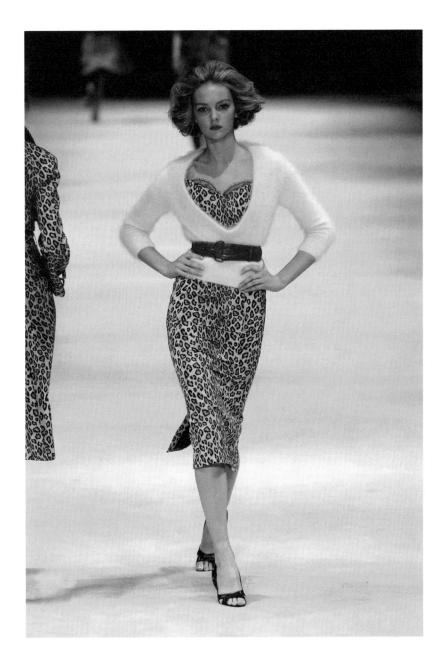

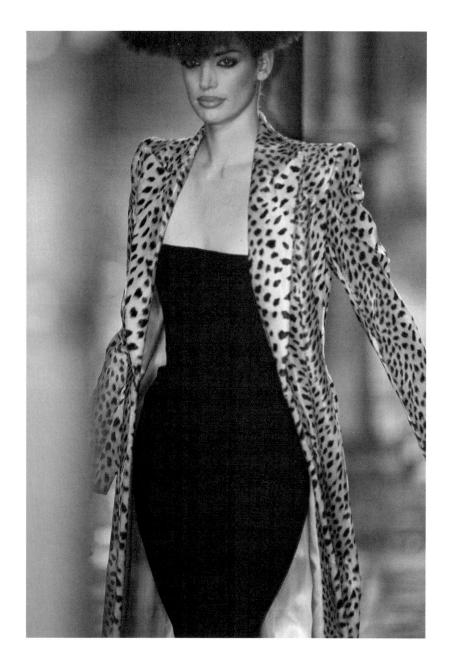

"Animals fascinate me because you can find a force, an energy, a fear that also exists in sex."

McQueen

used to refer to cis-women's sexual parts, so wearing a pattern derived from a predatory cat's coat is inherently intimidating for men and less confident women.

The woman wearing a floor-length cheetah-print coat, with strong broad shoulders in McQueen's Autumn-Winter 1997–98 collection for Givenchy was powerfully in command of her authority and sexual identity. A tight leopard-print dress, worn under a white fluffy sweater and brown leather belt by a model strutting with saucy self-confidence in McQueen's *The Man Who Knew Too Much* collection, clearly resurrected the 1950s sex kitten whose awareness of her sexual power was an act of

rebellion. Another blond in the same Autumn-Winter 2005–6 collection wore a leopard-print pencil skirt under a tan sweater. Although covered up, the print broadcast her complete connection to her desires and her ability to inspire lust and fear in others.

← For the venerable Givenchy house, McQueen presented sharp, classic, cuts with bite and irreverent details. His use of a leopard print celebrated his own feral nature within an establishment setting.

Find a
Second Skin

Leather is arguably the most natural material for McQueen's psychological commentary on sexuality, survival and humanity's complexity. A material obtained through a creature's death, leather is a constant *memento mori* and our everyday connection with mortality. Flexible, durable and often seen in sexual subcultures or nightlife, leather expresses darkness and resilience. *Vogue* once proclaimed, 'There's no such thing as a McQueen routine without a sinister psychological subtext or two.'

Two zip-dresses, both from his Spring-Summer 1998 collections, could have slipped effortlessly into London's BDSM scene. A slinky leather slip dress with a zip across the breasts would cover the torso but expose the wearer's nipples, if she wanted, while another with a thigh-to-collar zip could be discarded with just a quick movement. These dresses represented McQueen's familiarity with kink and its cultural signifiers. The smoothness of the second skin, with flashes of flesh exposed, was an erotic experience without human touch or further contact.

A black leather bodice embracing a leather bandeau top with a lace-like torso and skirt, created for McQueen's Spring-Summer 2003 collection, appears to be holding the wearer in a tight hold. A lilac leather sculptural mould, completely covering the model's head and torso but morphing into pronounced hips that hovered over a skirt of cream horsehair, was distinctively erotic. The moulding replicated a woman's nipples and navel, creating protrusions and a little divot. The impression McQueen's leather garment created was one of danger and also accuracy for people into the fetish scene. In McQueen's hands, leather was a true second skin — completely connected to the wearer and heightening her sensitivity to the world surrounding her.

→ Laser-lacerated leather appears like lace modelled to the model's body in a dress Isabelle Blow bought from McQueen's 2003 *Irene* collection.

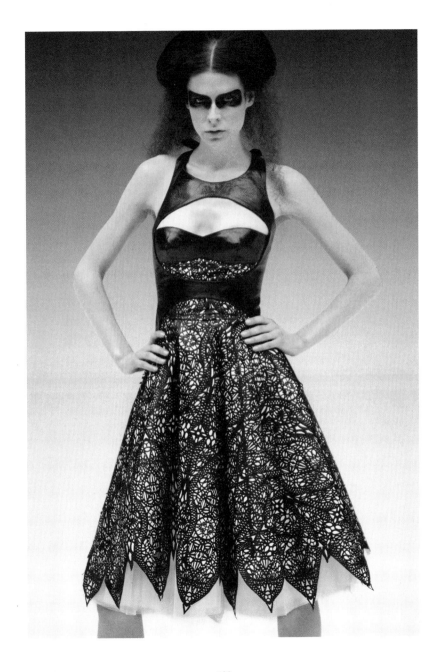

Love **Roses** and their **Thorns**

From his earliest collections, McQueen marked roses, the iconic British blossom, as one of his personal signatures. His relationship with England, as a conflicted but profound part of his identity, was constantly being engaged, deconstructed and challenged through his work. Roses were among the symbols McQueen used to address the tensions within his relationship to his Englishness, while simultaneously embodying his omnipresent connection with mortality. As he said, 'I used flowers because they die.' Roses, with their velvety petals but dangerous thorns are natural representatives of McQueen's whole approach to fashion – seductively sensual but dark, threatening, and potentially unnerving. He perforated roses through leather and wove them into burlap, created prints, moulded fabric into their distinctive form and embroidered them onto silk. Roses, like other consistent themes in his oeuvre, combine extreme pleasure and pain.

England's official flower, the rose is also associated with young British women with a quintessentially Caucasian ideal beauty, usually of pale colouring with blush cheeks, also referred to as 'English roses'. *Venus Verticordia*, Dante Gabriel Rossetti's 1864–68 painting of a pale Alexa Wilding as the goddess of love, surrounded by a profusion of roses, exemplifies the aesthetic associated with an English rose. McQueen created a similar vision of abundance for his *Sarabande* collection, where he covered a nude silk dress in dimly coloured silk roses and leaves. This image of flowers flushed of their vitality was the polar opposite of Rossetti's sensual splendour, appearing as a realistic portrait of love 'beyond its bloom'. He designed a mauve silk companion to this gown for the same Spring-Summer

→ Bringing fresh cut roses and their cloth counterparts together in silk gown for his 2007 *Sarabande* collection, McQueen demonstrated his complex relationship with morbidity and vitality.

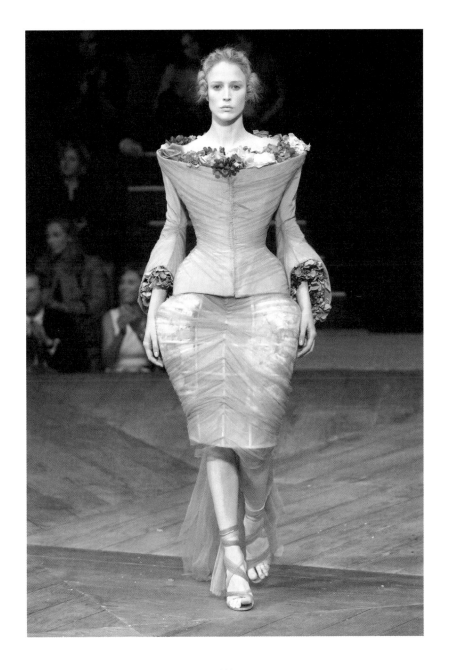

"I find beauty
in melancholy."

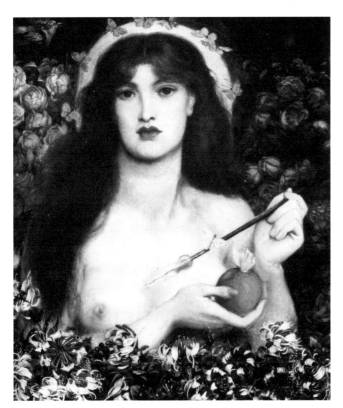

← The sensual and symbolic significance of roses for McQueen is shared by Dante Gabriel Rossetti. The iconic Pre-Raphaelite painter's Venus Verticordia (1864–68) conveys the beauty and danger that McQueen expresses in his kinetic artwork.

2007 collection. The exaggerated hourglass silhouette was constructed with delicately faded fabric. The crafted hips and waist, whose scaffolding was lightly visible through the sheer skirt, was counterbalanced by a profusion of fabric roses across the collarbone and around the model's forearms and wrists. Her neck and face, lightly powdered, appeared like another blossom in the bouquet. The flowers themselves, a collection of roses and violets, looked plump

yet drained of colour and vitality. McQueen described the palette for this dress as inspired by the Victorian photographer Julia Margaret Cameron's hand-painted prints. 'It is not white,' he said, 'it's dirty white. And, the pink is like the powder on the face.' The effect was less macabre than melancholic. It signified an awareness of aging and loss rather than death's intensity. As McQueen noted, 'I find beauty in melancholy.'

Add Volume, then **More Volume**

Excess was standard for McQueen, who threw giant explosives into the fashion world through his conceptual irreverence. As *The Independent* wrote early in his career, 'The shock of the new has to be just that: shocking, and if that sometimes leaves us fashion hacks tut-tutting like latter-day Miss Jean Brodies, or feeling distinctly off-colour, then so be it.' The intensity of his statements were standard and often discussed but less critical attention has gone to analysing how McQueen used scale and volume in his actual designs for impact. Often the intended results from his grand amounts of material was not shock but beauty. McQueen had great appreciation for fabric. He used material as a tool for expression but, like any genuine and great artist, his work demonstrated a deep sensual connection and understanding of his medium.

Action Painting, the canvas dress turned into art by robots shooting paint during his Spring-Summer 1999 collection, became one of fashion's most meaningful images at

the end of the twentieth century. Model Shalom Harlow employed her background in ballet to transform the experience of wearing a mobile canvas into a dance demonstrating anxiety and ecstasy. The dress itself, which started from a leather belt under her clavicle and descended into an enormous pyramid-shaped form to her calf, was simple and yet extraordinary because of its size. When Harlow swirled and made herself available to the advancing machines, the dress blossomed — as if welcoming the onslaught of yellow and black markings that transformed it from a pristine white cotton and silk form into a post-modern resurrection of Jackson Pollock.

A dress comprised of black shiny synthetic fabric underneath a corset of black leather with silver belt buckles was menacing, referencing McQueen's connection with BDSM culture, yet also intimidating because its proportions. The small waist expanded into an expanse of material that ended in a fishtail beyond the

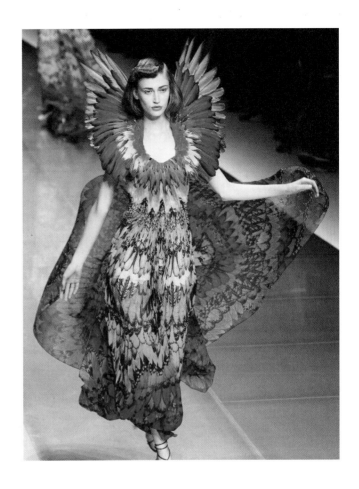

knee-high hem. A model seemed swallowed up by whorls of synthetic hair for McQueen's Autumn-Winter 2001 show. In 2003, for his *Irene* collection, McQueen presented a dress of pure, uncomplicated brilliance and splendour. Rainbow-coloured, inspired by birds of paradise, silk expanded from the model's bare arms to a cascading skirt, while a feathered collar surrounded her face. In contrast to this unmitigated joy, in 2010, Daphne Guinness paid homage to her dear friend's grand vision, following his death, by wearing McQueen's billowing black cape to pay her final respects to him.

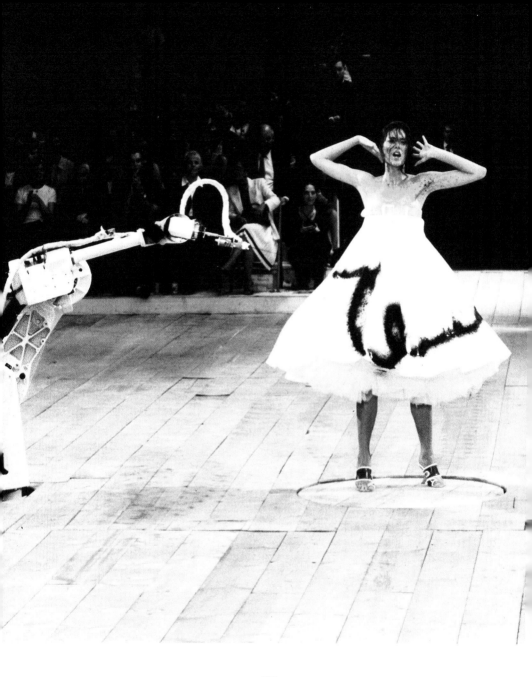

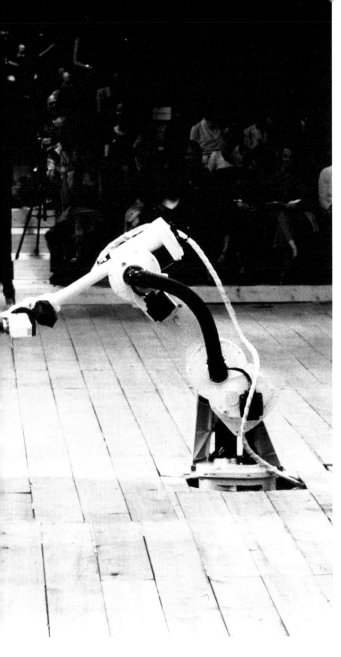

← Model and former ballet dancer
Shalom Harlow became a living
art installation for McQueen's
1999 catwalk collection.

Go on
Red Alert

McQueen had an acute awareness of the poignant connotations of red. Called by colour theorists 'the colour of extremes', red was an organic match for McQueen. His ever-present consciousness of peril and death was manifested in his aesthetic choices as well as in his narrative expression, and his use of red was very personal. His subjective embrace of red flowed from his personal story. McQueen's family tartan was crimson, black and yellow. The thin yellow lines and black accents empowered the red base, making the colour's strength and intensity even more striking.

He often added flashes and slashes of red against black to evoke associations with Goth iconography, BDSM sexuality and a

shocking violence. 'I use things that people want to hide in their heads,' he said. 'War, religion, sex; things we all think about, but don't bring to the forefront. But I do and force them to watch.'

A model's red knickers were visible underneath roses laser-cut into black leather for his Autumn-Winter 1997–98 catwalk, their striking colour suggesting danger. For *Voss*, a cascade of bright red medical slides, arranged like scales along the model's spine, transitioned into a burst of red and black ostrich feathers, looking like a mix of freshly spilt and then coagulated blood. For his Jack the Ripper-inspired early collection, McQueen presented a pinkish red frockcoat with a black pattern depicting a murder victim's hair floating in her own blood. A silver wool jacket with split sleeves revealing its red lining, made for Spring-Summer 1996, exposed a moulded plastic bodice encased with dead worms. This disquieting top was worn with a slinky red pencil skirt, turning the shock into enticement.

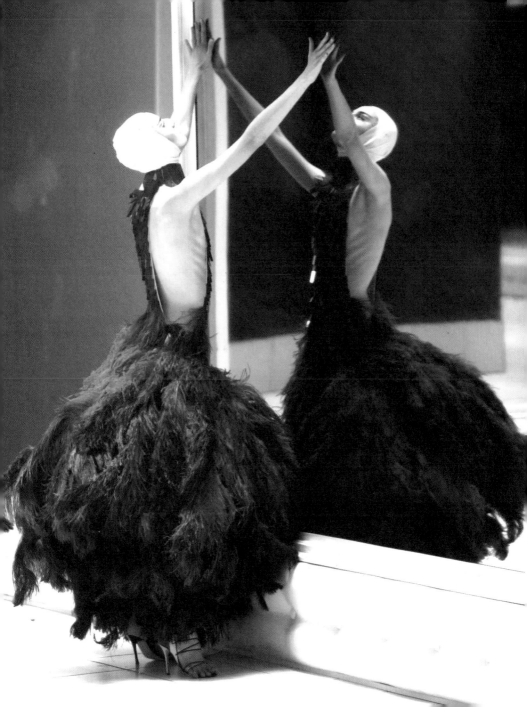

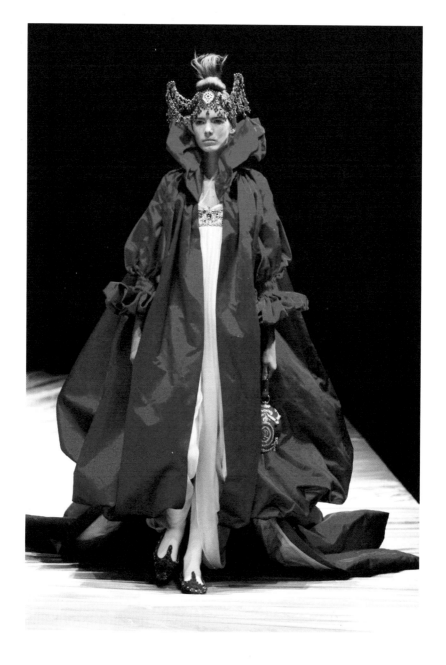

"I use things that people want to hide in their heads. War, religion, sex; things we all think about, but don't bring to the forefront. But I do and force them to watch."

McQueen

The horror of red, which McQueen represented with singular eloquence, was offset by his skilful use of red as emblematic of opulence. McQueen's most breathtaking red garment was worn by Daphne Guinness from his 2008–9 collection *The Girl Who Lived in the Tree*. A white, bejewelled, empire-waist gown can be seen underneath an enormous red silk cape. The sleeves are nipped in with accordion folds across the model's forearms and the same stitching runs under the collar, which blossoms to cover her ears and frame her face. The hem becomes a long train but the most significant expanse of material is towards the model's ankles, where the fabric appears endless and its rich crimson is incomparably luxuriant. On the catwalk, the model held a red lacquered purse with a red leather belt-like handle, its gold and red body identical to a massive Fabergé egg.

← An ivory white silk dress covered with a bright red coat was the theatrical showstopper in McQueen's 2008–9 *The Girl Who Lived in a Tree* collection.

Stitch it Up

Traditional handicrafts were largely absent from the catwalks in the nineties and noughties, the decades when McQueen dominated fashion. The designers defining the nineties, like Helmut Lang and Calvin Klein, were minimalists who used colour sparingly. Black was the standard among designers and their acolytes. When colour was used, bold colour-blocking was a common visual device and all detailed forms of adornment were rare. McQueen was among the few, alongside John Galliano, who revered craftsmanship and reviving historical looks and techniques. Embroidery, as a distinct and historically rich method of adornment, became a

→ Creating cascading greenery with embroidery and beading, McQueen crossed the line from fashion to wearable sculpture. The tapestries he created with thread, such as this 2001 look for *Voss*, were homages to cultural traditions and sensibilities that spoke to his sense of wonder and sensuality.

recurring sight on McQueen's catwalks, alongside technologically advanced forms of printmaking, mouldings and cuttings. He explained, 'When you see a woman in my clothes you want to know more about them. To me, that's what distinguishes good designers from bad designers.'

The craft of stitching thread or yarn into fabric to create evocative images, for decorative not repair or practice purposes, like reinforcing seams, has always probably been part of garmenting. The practice might date further but the earliest examples are from fifth-to-third centuries BCE China. The artistic significance of embroidery, as well as weaving, was codified in Western culture through the Ancient Greek myth of the goddess Athena battling with Arachne, a talented mortal, to produce the most beautiful and compelling cloth. Natural, raw, burlap used for a dress in McQueen's Autumn/ Winter 2003 show, became magnificent when embroidered with massive flowers and branches.

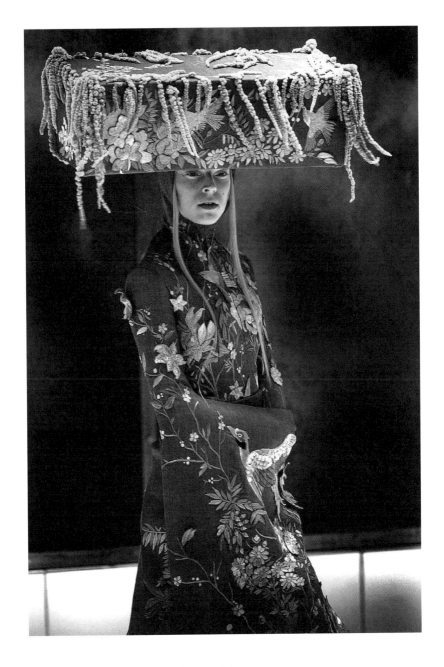

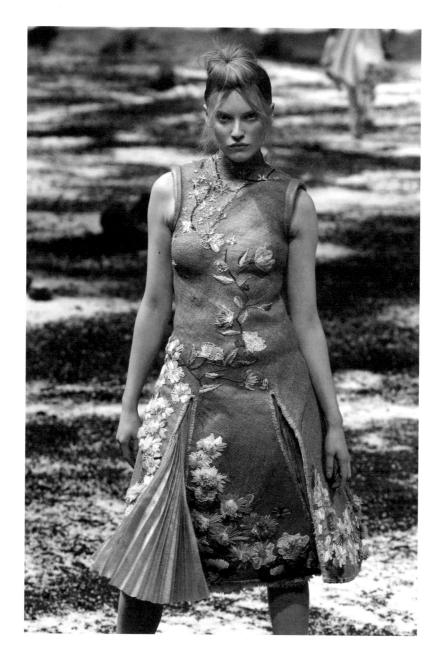

"When you see a woman in my clothes you want to know more about them. To me, that's what distinguishes good designers from bad designers."

McQueen

Requiring time and talent to create, embroidered clothing, religious objects and home décor became a luxury item for royalty and other elites across the world. The technique also became deeply interwoven into wealthy women's subjugation. McQueen's central thesis was always women's empowerment, so he probably very purposeful when harnessing and subverting embroidery's legacy. Denied access to scholarship or practical work, women before marriage were expected to devote much of their days to needlework, with the medium's inherent uselessness mirroring the restrictions on higher-status women's intellectual and practical lives. In Voss, a model appearing encased in red burlap dress embroidered with flowers, screamed through a spiked face shield dripping with onyx berries.

Gold flowers embroidered into cream-coloured pony skin for McQueen's 1997–8 collection were delicate contrasts to the dress's rough, raw, fur and form-fitting cut. A lilac silk jacket and floor-length skirt embroidered with flowers and fishes evoked the techniques assumed origins in China. Asian influences were most beautifully and dramatically presented in a jacket, hat and trousers for Voss, where crystals and embroidered plants turned grey wool into a living garden.

Celebrate
Classic **Curves**

'I want to exaggerate a woman's form,' McQueen explained, 'almost along the lines of a classical statue.' Although he emerged in an era when androgyny was celebrated and fashion's reverence for a straight-lined physique undermined traditional gender boundaries and unkindly prioritised extreme youth and skinniness, McQueen preferred an archetypically feminine silhouette. For him, a nipped-in waist, created by padding hips or drawing in the belly with a corset, exemplified a strong female form. The hourglass was his evocation of women's sexuality and power. He used belts, harnesses, corsets and phantasmagorical accessories to draw attention to the waist and its primacy in women's beauty.

One of McQueen's most extreme and otherworldly ways of celebrating the waist was a heavy aluminium and leather corset. Crafted to replicate the spine and ribs, morphing into a peaked tail, the corset showcased a human like a dinosaur in a natural history museum. The metal ribs, which wrapped around the model's own torso, attracted attention to the construction of her waist, while making every breath discernably pronounced. Metal coils completely covered a woman's torso for McQueen's *The Overlook* collection. Comparably prosaic, a leather harness built into a tweed jacket evoked traditional English hunting garb while highlighting the wearer's bust and ribcage through its tight form and illustrative seams.

The most intense corset McQueen presented was not worn by a cis-female but by Mr Pearl for the designer's collection *The Birds*, but slightly less extreme corsets continually formed parts of his collections throughout his career. A lavender and black

→ Shaun Leane's 'spine' corset holds the body in a tight embrace with aluminum and leather.

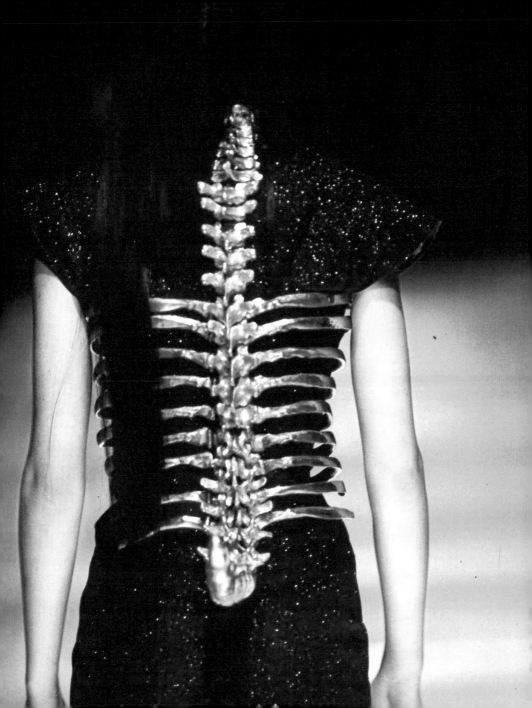

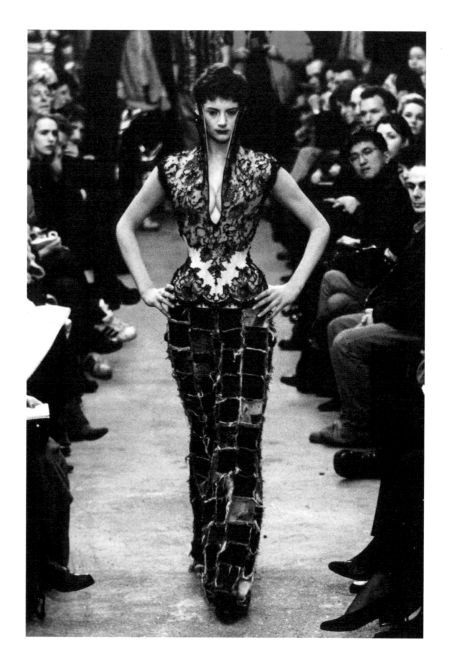

"I want to exaggerate a woman's form almost along the lines of a classical statue."

McQueen

lace corseted top, which culminated in an exposed cleavage and high-peaked neckline, appeared in his *Dante* collection. The visible boning underneath the jet beads and lace illustrate how faithful McQueen was to authentic corset techniques, adhering to construction and appearance to produce the experience of wearing a corset as well as its visual impact. For many, corsets are highly erotic and McQueen's tightening of women's waists was about the wearer, as well as her admirers. Explicit returns to BDSM were seen in leather woven corsets, like the one he decorated with bird's feathers and skulls for his 1997–98 Givenchy haute couture collection. A woman electing to bind her body in leather was empowering when women's curves were stigmatised generally. Although challenging gendered norms has societal benefits, so does promoting a potentially healthier aesthetic. According to McQueen, 'women should look like women.'

← Lilac silk appliqued with lace and jet beads, worn in 1996–97 by Honor Fraser, recalls Victorian ball gowns and heroines from the past.

Don't Let the Goth Die

McQueen was a forerunner in bringing a resurgence of Gothic narratives in the nineties from their subcultural niche and more mainstream manifestations into a more serious, artistically sanctified space. Although distinctly British in origin and expression, Gothic themes and iconography in art, literature, film and fashion defined nineties' culture in Europe, the UK and USA. Post-modernism, fin-de-siècle anxiety, the AIDS crisis, economic collapse and other sociopolitical influences inspired a more mainstream embrace of a long-standing aesthetic centred around supernatural dangers, repressed horrors, sexuality merged with death and what nineteenth-century psychoanalyst Carl Jung termed 'the shadow'. Jungian theory was full of internal unknowns and potentially dark forces within

→ Black duck feathers create a threatening but seductive creature on McQueen's 2009–10 *The Horn of Plenty* catwalk.

the psyche that Gothic imagery depicted as vampires, ghosts and other sinister forces. For McQueen, the themes found in Gothic high art, by artists such as Goya, Munch, Henry Singleton and Evelyn De Morgan, blended with references from mass-market forms of Goth, such as the popular series *Buffy the Vampire Slayer* and film *Bram Stoker's Dracula*.

Originating in UK nightclubs in the eighties, the Goth youth subculture, with its penchant for black and all things macabre, had camp qualities that were to become more mainstream a decade later. They appealed to McQueen's ability to bridge perceived class and cultural divides. He overrode distinctions between 'high art' and 'low culture' gracefully but, as Catherine Spooner, cultural critic and professor at Lancaster University, explains, McQueen's work was Gothic, not Goth. 'Hauntings, revenants, ancestral curses and uncanny returns are the most definitive property of the kind of Gothic found in films and books.

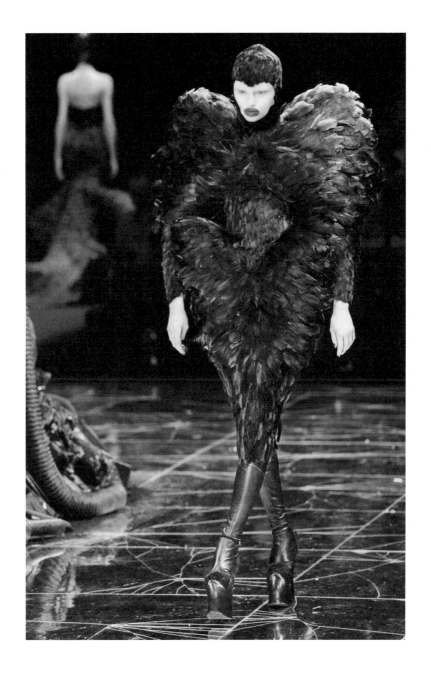

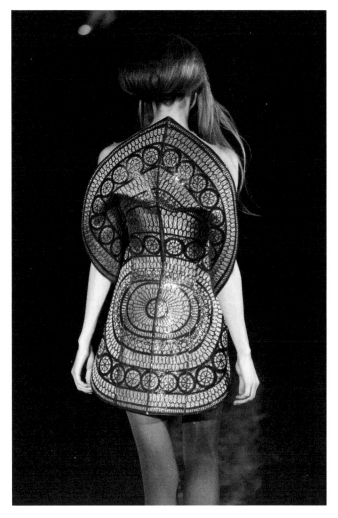

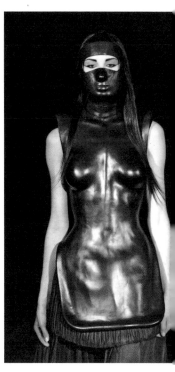

↑ A moulded leather bodice, partially covering the face, evokes high-end BDSM kink and horror-movie imagery in McQueen's 2007–8 show dedicated to the women murdered as witches in 17th century Salem

← Leather patterned and crafted to fold over the body creates the illusion of a decaying outer layer, evoking classic horror-movie tropes of entropy and transformation.

"'... an enduring truism about the cultural phenomenon known as the Gothic is that it simply will not die."

Catherine Spooner

The past also weighs heavy on the present for McQueen.'

In Memory of Elizabeth Howe, Salem, 1692 was McQueen's Autumn-Winter 2007–8 homage to a distant ancestor that his mother had taught him was hung as a witch in Salem. The Salem Witchcraft Trials of 1692 can be seen as a cultural lesson in mass hysteria, the persecution of girls and women, and the danger of believing gossip above investigation. McQueen's fascination with his family's history, especially its darker elements, compelled him to envision the victim as a warrior with moulded leather corsets, her mouth hidden, both silenced and ominously missing. Pagan iconography adorned accessories for the collection as one example of these elements in his art, which spoke to Gothic themes of persecution, revival, revenge and insuppressible desire. As literary critic Catherine Spooner observes, 'an enduring truism about the cultural phenomenon known as the Gothic is that it simply will not die.'

Celebrate your Culture's Complexity

Any exploration of McQueen starts and finishes with tartan. The symbolism and significance of the material representing McQueen's heritage and strong sense of Scottish identity has been explored in previous chapters, and the uncanny fortune of his family's signature cloth being comprised of blood red and black with thin jolts of yellow. This colouration and pattern represents McQueen's essential character, personality, ethos and aesthetic, as well as representing his family lineage. He used this tartan throughout his career in grand and subtle ways. For a designer, whose work was rarely redundant but was recognisably his own, the tartan was a rare regular theme, creating a through-line that

→ Tartan, whether representing McQueen's clan or borrowed from another pattern, became his medium to address complexity and trauma from his heritage.

connected his various collections over the years and demonstrated his commitment to authenticity and creative integrity.

McQueen attended the Met Costume Institute Gala, fashion's most prestigious annual event, in 2006 with the actress Sarah Jessica Parker. He wore a classic kilt and his family tartan as a wool shawl draped over his shoulder, in accordance with tradition, while she wore a flashier version, combining a satin tartan draped shawl, fashioned with a floral pin at her shoulder and a prom-dress-like frock beneath. The exhibition they were attending was 'Tradition and Transgression in British Fashion'. SJP was an incongruous match for the dress and Anglomania mood of the time, but she was, fresh from *Sex and the City* fame, one of fashion's most influential ambassadors to the mainstream. McQueen adorning this widely popular actress's frame in a mass-media-friendly version of his family tartan, while wearing an authentic version himself, demonstrated the versatility he found in his signature material.

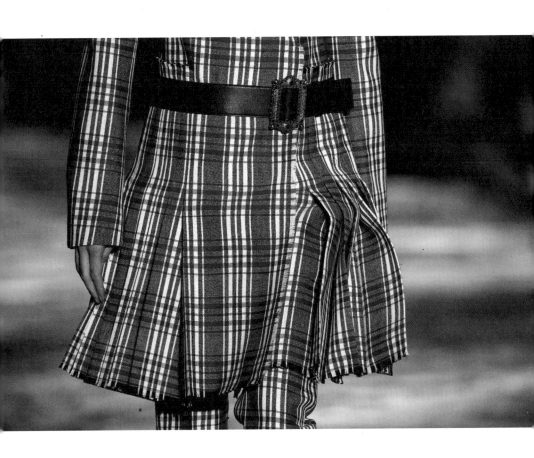

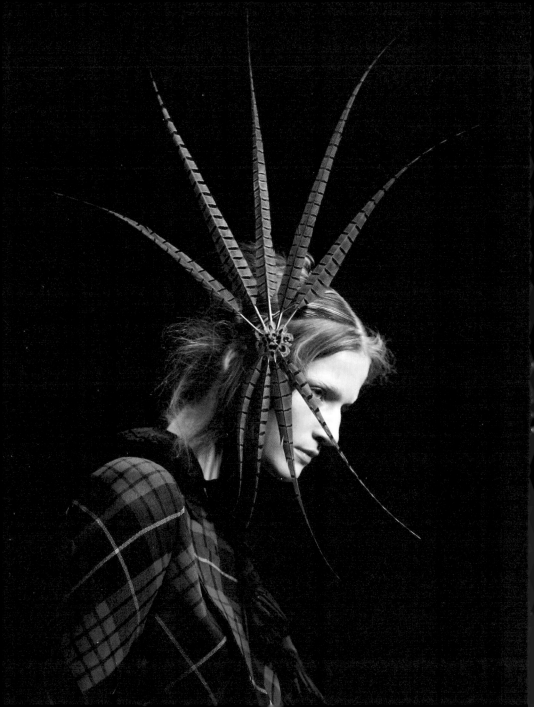

"There is nothing romantic about [Scottish] history."

McQueen

McQueen used tartan to address Scotland's difficult history as a colonised country. 'There is nothing romantic about its history,' he said in response to the British kitsch fascination with haggis and bagpipes. One of the earliest iterations of McQueen's tartan were two subversive suits seen in *Highland Rape*, Autumn-Winter 1995–96. Cropped above the naval and open across the bust, a jacket of green wool with a tartan torso and labels, hovered over a tartan pencil skirt, demonstrating the fabric's thickness and strength, as well as the model's vulnerability and exposure. A tartan frockcoat, which left the model's torso exposed but covered her neck and supported a lace collar, embodied the spirt of defiance McQueen expressed throughout the collection. In 2006–7, McQueen's tartan became more structured and elegant for the *Widows of Culloden*. Dresses and suits with jet-bead and lace details crafted from his signature tartan showcased his extraordinary tailoring abilities and masterful use of diverse materials and references, but still carried the irreverence, resilience, strength and challenge that defined his as an artist and person.

← McQueen's used his family tartan to assert his claim over the print, which he felt was appropriated and Anglicized. He never lost touch with his identity or allowed his followers to forget the painful parts of history.

Glossary

Alfred Hitchcock (1899–1980) – Dubbed the 'Master of Suspense', iconic British film director Hitchcock's horror and suspense movies included *Dial M for Murder* (1954), *Vertigo* (1958), *Psycho* (1960) and *The Birds* (1963). See *The Birds*; Horror films.

Ann Demeulemeester (1959–) – Belgian fashion designer whose eponymous label defined a strong, minimalist, asymmetrical aesthetic in the nineties. See Antwerp Six/Antwerp School.

Antwerp Six/Antwerp School – The influential group of six fashion designers who graduated from the Antwerp School of Fashion between 1980 and 1981, including Dries Van Noten and Ann Demeulemeester. Promoted a minimalist, experimental, androgynous aesthetic, including deconstruction and artistic references.

Avant-garde – New and experimental ideas and methods.

BDSM – The umbrella term for a range of sexual practices practised by consenting adults, including bondage, discipline (or domination), sadism and masochism.

Bumsters – McQueen's signature low-rise trousers, cut below the pelvic bone and exposing the top of a wearer's buttocks.

Cis/cisgender – this term denotes a person whose gender identity aligns with their birth gender. This term was developed by the transgender community to de-normalise the assumption that gender identity and biological gender are automatically aligned.

Crown of Thorns – Jesus, according to the *New Testament*, was forced to wear woven thorns around his head during his crucifixion as part of his torture.

***Dante* collection** – McQueen's Autumn-Winter 1996–97 collection, staged in Christ Church, in Spitalfields, and devoted to themes of war and historical atrocity.

Dante's *The Divine Comedy* – An allegorical narrative poem by Dante Alighieri, written c.1308–20, imagining his travels through Hell, Purgatory and Heaven.

Día de los Muertos – A traditional Mexican holiday on which families and communities celebrate the dead through joyful, life-affirming folk art and festivals.

Deconstructivism – A movement in fashion and art focusing on the techniques and mechanisms of creative construction, exposing seams and unfinished hems to celebrate the craft of creation. See Antwerp Six/Antwerp School.

Dole, on the (colloquial, UK) – To be claiming unemployment benefits from the state.

Dries Van Noten (1958–) – Belgium fashion designer dubbed 'one of fashion's most cerebral designers' by the *New York Times* for his move from minimalism to colourful abstraction. See Antwerp Six/Antwerp School.

Eye – McQueen's Spring-Summer 2000 collection, shown in New York, with references to traditional Muslim dress, bondage and sportswear. McQueen claimed the collection was a critique of Islamophobia.

Gothic – An aesthetic and a set of themes in art, literature and fashion focusing on death, decay, sexuality and beauty in the grotesque. Characterised by morbid themes, a Gothic aesthetic is 'dark' in nature.

Hans Bellmer (1902–75) – A German surrealist artist, Bellmer produced photographs and sculptures of life-sized pubescent female dolls, often contorted and poised to appear like corpses known as La Poupée.

Horror films – A cinematic genre devoted to morbid themes and messages, designed to induce fear in viewers.

Jack the Ripper – A serial killer who murdered and mutilated impoverished sex workers in London's Whitechapel district in the late 1880s. His identity was never definitively revealed, despite ongoing cultural fascination with his crimes.

Joel-Peter Witkin (1939–) – Art photographer known for classically beautiful and subtly erotic images of death, decay and socially marginalised groups.

John Galliano (1960–) – British fashion designer whose theatrical catwalk collections were celebrated for their artistry, intellectual references and specular execution.

Joyce McQueen (1934–2010) – Alexander McQueen's mother and his greatest support and influence. She taught genealogy and was passionate about her family's history.

Memento mori – An artistic and literary trope symbolically representing the ubiquity and inevitability of death. This genre of art serves as a reminder that death is omnipresent and interwoven into life.

Savile Row – A legendary street in Mayfair, London, where top-tier tailors make bespoke men's suits. Since the area's establishment in the 1730s, English and international elites have favoured it.

The Birds – Alfred Hitchcock's 1963 iconic film, interpreted as an allegory for stigma against female sexuality, tells the story of a glamorous woman (Tippi Hedren) who pursues a handsome bachelor (Rod Taylor) before a town's birds become a mysteriously murderous mob attacking humans.

The publishers would like to thank all those listed below for permission to reproduce the images. Every care has been taken to trace copyright holders. Any copyright holders we have been unable to reach are invited to contact the publishers so that a full acknowledgement may be given in subsequent editions.

Alamy: 23 (Renault / Globe / MediaPunch); 52 (PA Images/ Alamy Stock Photo).

©**FirstVIEW/IMAXtree.com:** 11; 12; 17; 21; 25; 29; 31; 35; 36; 39; 46; 51; 55; 57; 62; 71; 73; 77; 78; 81; 83; 84; 87; 88; 94; 101; 105; 109; 111; 116; 119; 123; 124; 127; 128; 132.

Getty: 15, 123 (Victor Virgile); 18 (Catherine McGann); 27 (Martyn Hayhow); 33 (Alex Lentati/ANL/ Shutterstock); 41 (Mike Marsland); 42 (Chris Jackson); 45 (Michel Dufour); 59 (Stuart C. Wilson); 61, 106 (Thierry Orban); 65 (Dimitrios Kambouris); 67 (Dave Benett); 68, 115 (Lorenzo Santini); 75, 136 (Stephane Cardinale - Corbis); 93 (Stephen Lovekin); 97 (Andy Paradise); 102 (Photo Josse/ Leemage); 113 (Photo 12); 120 (Frederic Bukajlo); 131 (Pascal Le Segretain); 135 (Estrop).

Rex: 98 (Alex Lentati/ ANL/Shutterstock).

Index

First published in 2021 by
Frances Lincoln Publishing
an imprint of The Quarto Group.
The Old Brewery, 6 Blundell Street
London, N7 9BH,
United Kingdom
T (0)20 7700 6700
www.QuartoKnows.com

Text © 2021 Ana Finel Honigman

Ana Finel Honigman has asserted
her moral right to be identified
as the Author of this Work in
accordance with the Copyright
Designs and Patents Act 1988.

All rights reserved. No part of
this book may be reproduced or
utilised in any form or by any means,
electronic or mechanical, including
photocopying, recording or by any
information storage and retrieval
system, without permission in writing
from Frances Lincoln Publishing.

Every effort has been made to
trace the copyright holders of
material quoted in this book. If
application is made in writing to
the publisher, any omissions will
be included in future editions.

A catalogue record for this book is
available from the British Library.

ISBN 978 0 7112 5906 5
Ebook ISBN 978 0 7112 5908 9

10 9 8 7 6 5 4 3 2 1

Design by Intercity

Printed in China

FSC
www.fsc.org

MIX
Paper from
responsible sources
FSC® C016973

Thank you to my
wonderful parents,
Zoom, Henry, Frank,
Abe, my SW community,
Baltimore, and most
of all, Libby Brown.